Learn to Paint

Buildings
in Watercolour

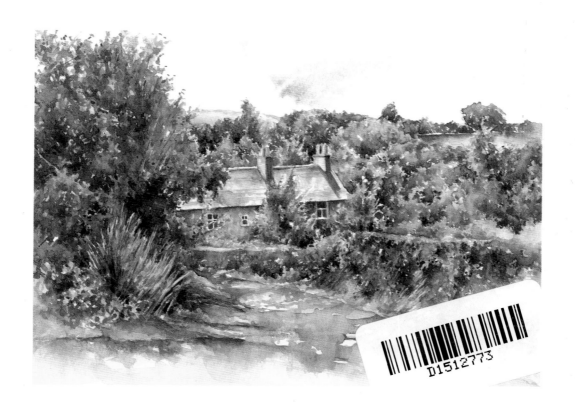

Richard Taylor

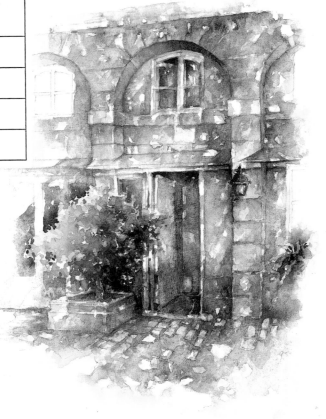

First published in 2002 by
Collins, an imprint of
HarperCollins*Publishers*
77-85 Fulham Palace Road
Hammersmith
London W6 8JB

The Collins website address is www.**collins**.co.uk

Collins is a registered trademark of HarperCollins Publishers Ltd.

06 08 10 09 07 05
2 4 6 5 3 1

A catalogue record for this book is available from the British Library

Editor: Geraldine Christy
Designer: Caroline Hill
Photographer: George Taylor

ISBN 0 00 719909 0

Colour reproduction by Colourscan, Singapore
Printed and bound by Printing Express, Hong Kong

Previous page: **Secluded Cottage** 25 x 34 cm (10 x 13 in)
This page: **Mediterranean Courtyard** 24 x 21 cm (9 ½ x 8 in)
Opposite: **Terrace Brick Building** 28 x 15 cm (11 x 6 in)

Contents

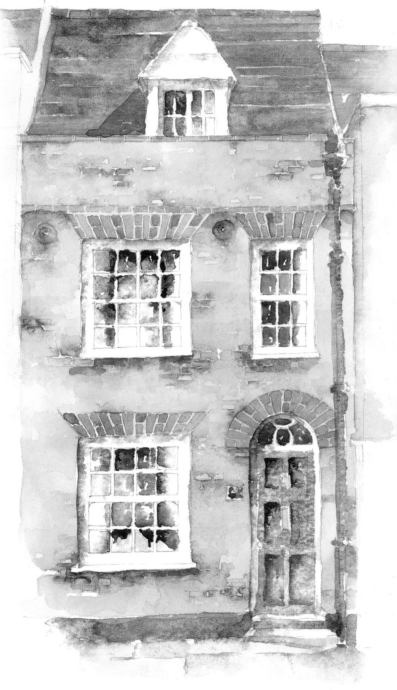

Portrait of an Artist

Richard Taylor was born in the North London suburb of Enfield and walked to school every day past ivy-clad Georgian houses and timber-clad cottages, the visual appeal of which he has never forgotten.

On leaving school, Richard looked for a way of combining his interest in painting and his love of communicating the subject, and decided to train as an art teacher. He gained distinctions in all of the 'classroom practice' sections and qualified in his chosen profession. A growing fascination for the alchemy and history of art, however, led him a stage further, resulting in his gaining a degree in Contextual Art Theory.

Richard then felt that he needed to travel to find new inspiration for his art, and set off for the mountains of Wales, Cumbria and the

▲ Most of Richard Taylor's paintings are produced in the studio, working from references.

Scottish islands. Before too long he was training with mountain rescue teams and embarking on expeditions to the Alps, Iceland, and the Rocky Mountains. Several exhibitions followed, including a show at the British Mountaineering Council Conference. One critic observed: 'With drawing like this, why bother painting!'. Richard took this advice and began to use drawing as a major feature of his work. Watercolour soon became the natural ally and a clear artistic direction was found.

On a particular visit to the Shetland Islands Richard was sketching the rock faces and cliffs when bad weather forced him back inland. When he started sketching the crofts and cottages he soon realized that the textures and shapes of buildings were really no different to the rocks and mountains that had fascinated him for so long. From that point on, the built environment became his main source of inspiration.

Richard now combines his skills and work as a watercolour painter with his highly regarded teaching abilities. He is the author and illustrator of ten books on art techniques, has presented a number of videos, and worked as consultant to a major art magazine publisher, as well as contributing to numerous art instructional magazines.

Richard lives on the North Essex coast with his wife, son and dog, and finds inspiration in the structure, shapes, colours and textures of towns and cities. He teaches on courses at a London art school and in his own teaching studio, as well as demonstrating at most major British art shows throughout the year.

▼ **Village Main Street**
27 x 40 cm (10½ x 15½ in)
Buildings that have been added to are always a pleasure to paint.

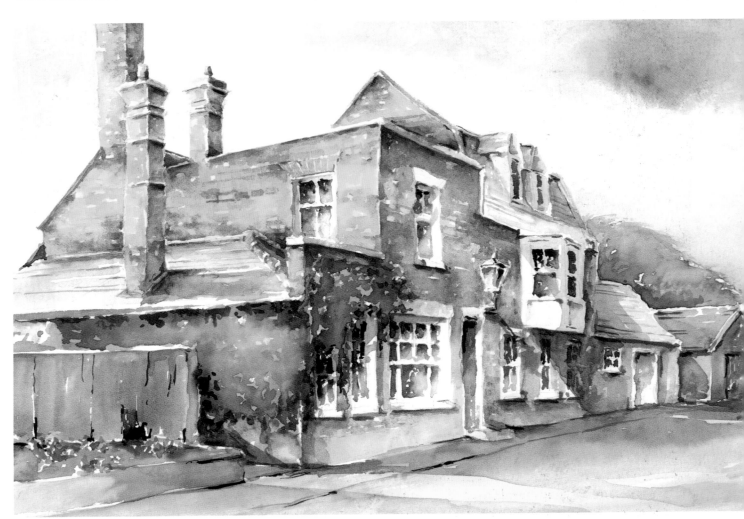

Introduction

One of the beauties of watercolour is its versatility. With the simplest of equipment you can achieve good paintings of nearly any subject, especially buildings. It is not unusual for me to use only four paints when sketching and painting buildings. Alternatively, you can achieve a highly finished and finely crafted picture using a whole range of watercolour paints, creating subtle tones and nuances as you mix and blend the many colours available to you.

Simplicity is the key

Here lies one of the first concerns that people have when starting to use watercolour paints: 'What on earth are all of these different paints for?'. The answer is simple – ignore the question until you feel that you are ready to try some new, slightly different colours or to experiment with some of the unusual and exotically named paints. Throughout this book you will find that I do not often use more than six or eight paints in any one picture – sometimes only four or five – and I strongly recommend that you do the same.

Making a start

Buildings come in many shapes and sizes and, rather as with your equipment, I advise that you start with a simple, small building. If you wish to start by painting an entire building it is probably best to position yourself so that you are looking at it straight on, eliminating perspective. This gives you the opportunity to concentrate on applying the paint freely and creating the range of tones and textures that you are likely to see.

Alternatively you may wish to select a section of a building on which to practise. A decorative doorway with some symmetrical

ironwork, or a window with a variety of brick types surrounding it, for instance, are excellent subjects to 'get the feel' of the media and to help you to understand exactly what you can do with watercolour.

Using water

Watercolour paints require water – but exactly how much do you need to paint with? There is no one answer to this question as the act of painting is not measured with scientific accuracy. My advice is to use more rather than less. You can always mop up water with a sponge or kitchen roll if you feel that you are using too much, but once you start to paint and the paper is marked it is not so easy or effective to add more water to the paper.

I like to use water to 'carry' the paint, allowing areas of stone and brickwork to be created out of the drying process. This means

▼ **Woodland Shelter**
19 x 23 cm (7½ x 9 in)
The way in which natural building materials can blend into their environment is always of interest to the artist.

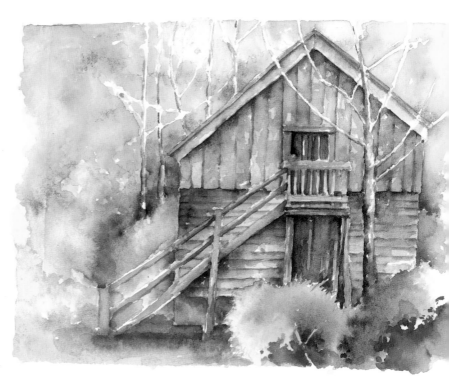

that I do not have to fiddle about with a small paintbrush trying to paint a few selected, individual bricks. As the paint dries the colours separate and form different tones and shapes, often suggesting brick or stone.

Economy of line and wash

Try to be as economical as possible with your use of lines and application of paint – the fewer and less the better. Watercolour is a medium that lends itself to spontaneity and a fresh, uncluttered approach. Much of my painting technique involves leaving flashes of white paper to represent highlights and to suggest reflections. White paint is not so effective as it covers the textures of the paper and appears dull and flat. Sometimes the sections that you leave out are more visually important than the sections you paint in.

The pleasure factor

Finally, painting for pleasure has to be the overriding reason for taking up this activity. So, experiment – try to use some of the ideas in this book and make them your own. But most of all, do not be afraid of making a mistake or 'getting something wrong'. That, after all, is only an opinion!

▲ **Georgian House Front**
24 x 34 cm (9½ x 13 in)
The effects of foliage surrounding a house are more noticeable depending on the season.

◄ **Stone Wall Textures**
22 x 28 cm (8 x 11 in)

7

Materials and Equipment

Another beauty of watercolour is that the painting equipment may be quite simple. A single brush, a couple of paints and some water are all that you really need to start. Personally, I use only three brushes in any one painting – one large, one small and one medium – and a tin containing no more than twelve paints.

Paints

Watercolour paints come in two distinct forms – in tubes or pans. The paint in tubes is quite sticky and needs to be squeezed out onto a palette. Tubes are particularly useful for very large paintings where a lot of paint is required to cover a large expanse of paper, or for when you want to create a very deep, strong application of colour. They will, however, dry out if left for long and, over

a period of time, will solidify in the tubes (not to mention the problem of the lid becoming stuck if paint has leaked around the edges).

Watercolour pans (or half pans) are often bought in metal or plastic sets that will usually have a lid that doubles as a mixing palette. Pans have the advantage of being highly portable and are much less troublesome. You will, however, find it difficult to 'work up' a lot of paint from pans if a large amount is required.

Whichever type of paint you choose, you will find that the colours can be bright, vibrant and very easy to mix.

▼ Watercolour pan paints are invaluable for soft, translucent washes. Tube paint is capable of providing much stronger, darker paint and could almost be used neat for real strength of tone and colour. I find that a combination of the two works particularly well.

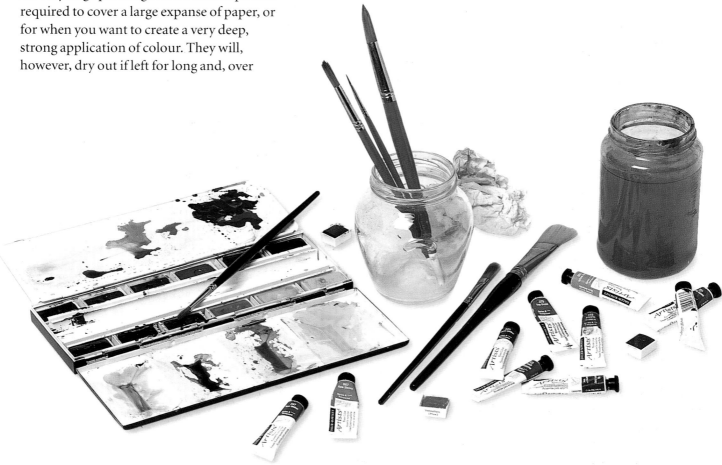

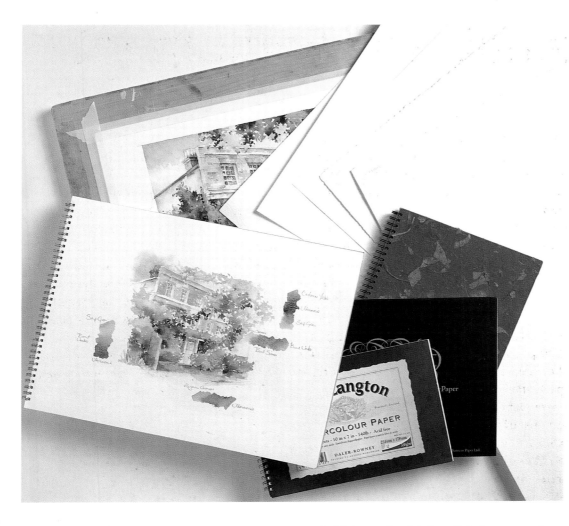

◀ Watercolour paper is available in sheet or sketchpad form with many different surfaces. Try to find one that suits your preferences, and then stick with it.

Paper

Watercolour paper comes in a variety of types, qualities and sizes. Large sheets of paper can be bought loose and all manner of sketchpads can be found with a variety of different bindings. There are, however, a few guidelines that will help bewildered shoppers.

Watercolour paper is classified by weight and texture. The weight is measured in gsm (grams per square metre) or lbs. A 300 gsm (140 lb) paper is a suitable, medium weight and will often be found in sketchpads; 400 gsm (200 lb) is a very strong weight and will stand a lot of punishment; 650 gsm (300 lb) and over takes you into the expensive, specialist field of paper and is best left until you have gained a little experience.

The surface quality of paper is specified in three categories. The most common is 'Not'

or Cold Pressed – this is a slightly textured, general-purpose paper. Smooth or Hot Pressed is a smooth, textureless paper that is good for line drawing, and Rough is a highly textured paper.

Many art shops sell small sample packs of the different qualities of paper to help you decide which will best suit your requirements.

Experiment to find out exactly how your paper will react to water and paint.

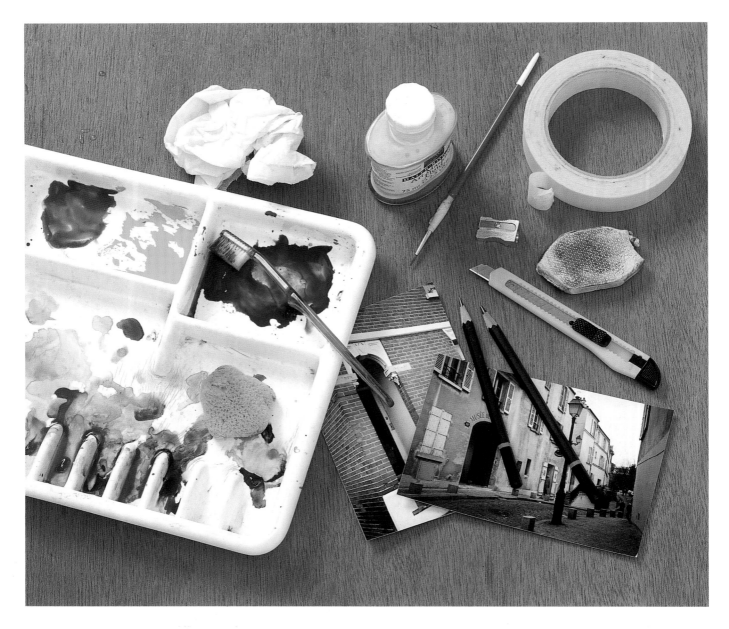

Other items

While watercolour painting requires a limited number of 'tools' to begin with, you will soon collect a set of important peripheral items.

In my studio I always have masking tape and masking fluid handy. The tape is used to hold the paper in place and the masking fluid is occasionally used to mask out any delicate areas that need to be maintained as pure white paper. The fluid can be applied with a number of implements, including an old toothbrush for spattering and an old, thin brush for application in lines.

For drawing I usually employ either a 2B or 6B pencil, a sharpener and craft knife. A putty eraser is useful for correcting mistakes and for removing pencil marks without damaging the surface of the paper. I also find it helpful to have some kitchen roll handy; this is ideal for blotting excessive water from paper.

Many artists have a pot in their studio that contains their own, highly personalized bits and pieces – twigs for applying masking fluid, toothbrushes for flicking and spattering, cotton buds for removing paint, and so on. With time you will soon discover which odd items work for you.

▲ A collection of peripheral, yet important, items that I frequently use in my painting.

Outdoor kit

For working out of doors I keep a simple set of very portable equipment ready and available in a backpack.

This kit includes a tin of half-pan paints with a small retractable paintbrush and built-in mixing palette. I also like to use a small plastic clip-on water container that will hold just the right amount of water for quick sketches. Cartridge pads for pencil sketches and ring-bound, hard-backed watercolour pads for painting are the two main surfaces that I work on out of doors.

Two other items I find essential are a 35mm transparency mount, and a compact camera. The mount acts as a viewfinder; it allows you to visually compose the picture by holding it at arm's length and moving it around until you can see the correct composition. The compact camera allows you to capture on film some of the busier or more complex aspects of the site visited, useful for future reference. While you can never beat the spontaneity of a fresh, uncluttered on-site sketch, however inaccurate it may be, you might like to supplement your source of references with a photo or two. This is particularly useful for capturing decorative or elaborate architectural detail.

Take a bottle of water with you if you are visiting a site that may not have a water supply handy.

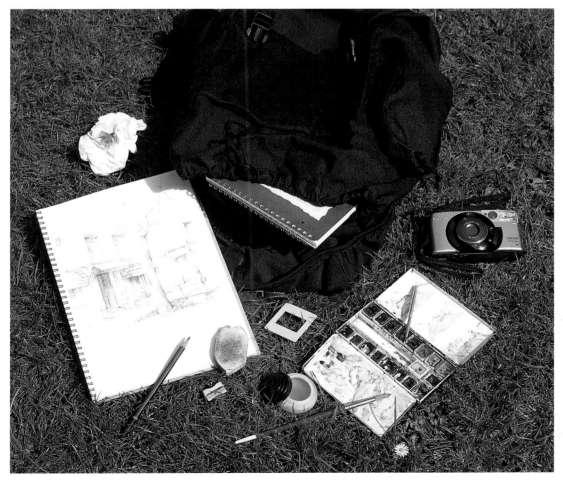

◀ Field equipment should be light and easily portable – just like this typical collection of sketching materials.

Watercolour Techniques

Watercolour is a medium that requires some control if used to its fullest potential. Other paint media tend to stay where they are put, but watercolour can be used to best effect when used with a lot of water. This takes some practice, but you will soon learn to predict how the paint and water will work together.

Basic wash

Watercolour paints are translucent when wet. This means that the surface to which they are applied will, in some way, show through. So, when watercolour paint is applied to plain watercolour paper it will dry to a fairly light tone as you will also see the white paper. This occurs because the pigment in watercolour paint is granular, and is held in suspension by gum arabic.

When watercolour paint has water added it becomes a 'wash' and can be applied freely with a brush. As the wash dries onto watercolour paper the water evaporates and the gum dries, 'holding' the coloured pigment on the paper surface. The light then travels through the translucent gum, reflects from the granular pigment and the textured paper, and appears to our eyes as colour.

This process of 'washing' can also be used to apply wet colour on top of a previously applied wash. The result of this will be light passing through two layers of paint before reaching the paper surface, reflecting a slightly duller colour.

This change in colour is something to be aware of when starting out with watercolour paint. Your first wash will usually be very bright and pure. A wash laid on to this will affect the colour, however, producing a slightly muted tone of the original wash.

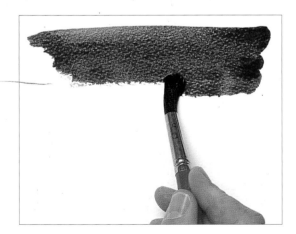

▲ For a basic wash apply the paint evenly with a watery mixture. Use a large brush for this.

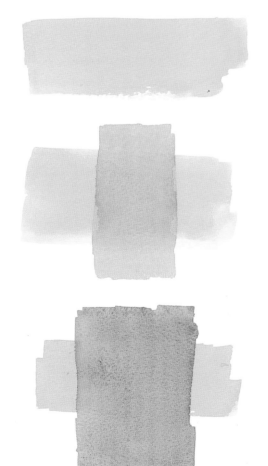

◀ This one-stroke application of paint was pulled from left to right using a flat-headed brush, and left to dry.

◀ Here a thin wash of paint was applied vertically across an earlier wash that had dried. The colour of the first wash has strengthened the colour of the second wash where the two cross over.

◀ A very thick or strong wash of paint does not allow the underwash to work so effectively.

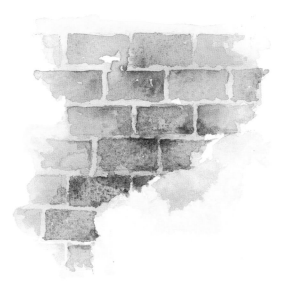

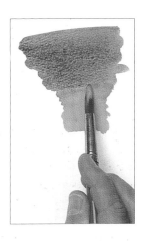

other hand, if you allow your paper to dry, you will only achieve another hard-edged brushstroke. The key is to wait until a sheen appears on the paper surface: this will tell you that the fibres of the paper are damp, but that the surface water has evaporated. This is the moment to apply wet paint to the paper. Using the tip of a paintbrush, place the paint at the centre of the area you wish to work and the bleed will gently flow outwards, soaking into the fibres of the paper and drying without a hard line.

▲ In this study of brickwork a Raw Sienna underwash enhances the quality of the brick colour (mixed with Burnt Sienna and Burnt Umber) and also represents the mortar visible between the bricks. The brick colours have separated, creating tones.

▼ The rust bleeds from the hinges on this old door were created by painting the rust colour (pure Burnt Sienna) on to the damp wood (Burnt Umber and Cobalt Blue) and stone (Raw Sienna and Burnt Umber) colours.

▲ For wet-into-damp wait until the surface water has evaporated.

Too many applications will make the final colour flat and lifeless. Try to limit yourself to a maximum of three washes, but one or two are by far the most effective.

Wet-into-damp

Sometimes you will want to achieve a softer effect than that of a straightforward wash, since this will always dry with a hard edge when applied to dry paper. To achieve soft watercolour bleeds you need to dampen your watercolour paper with a large brush first. This technique is best suited to stronger watercolour papers – 300 gsm (140 lb) upwards. Lighter-weight paper cockles if too much water is applied, making it difficult to work on.

This technique needs to be carried out quickly and decisively as timing is important. It also requires practised judgement and patience on the artist's part. If you apply paint to waterlogged paper it will run around the surface of the paper making puddles, become dilute, and eventually dry where it sits, often with a hard line. On the

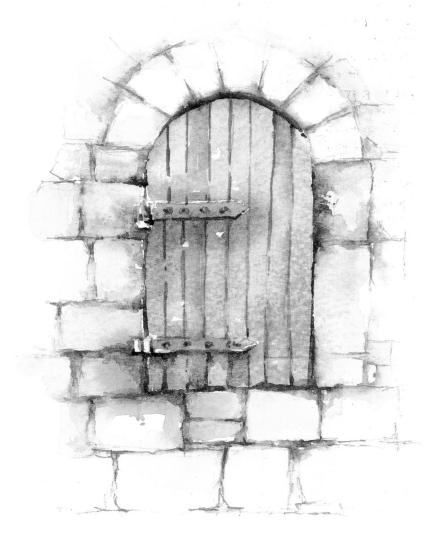

Wet-into-wet

Textured building materials – especially old, weatherworn stone and stucco or plaster – are ideal subjects for painting wet-into-wet. With this technique you will lose some control over the final outcome of your painting, but the results can be particularly pleasing.

► Experiment with wet-into-wet technique – the more water and paint used the better the effect.

Speed is important for this technique as you cannot afford to let the paper dry. The first application of water to the paper must be applied with a large wash brush. Soak the area that you want textured and then add as much paint as you like. You can even apply several differently coloured paints at the same time, then sit back and watch as they flow into the surface water and bleed naturally, albeit in differing quantities. Eventually the paint will dry on the paper, leaving all the paints that you applied blended and mixed in a quite unpredictable way, with a selection of watermarks to add to the ageing and staining effect that time has on stone, brick and plaster.

You can, of course, add more paint at any time in the drying process. This will create even more uneven drying rates, and consequently an even greater variety of colour blends and mixes to produce an impression of texture.

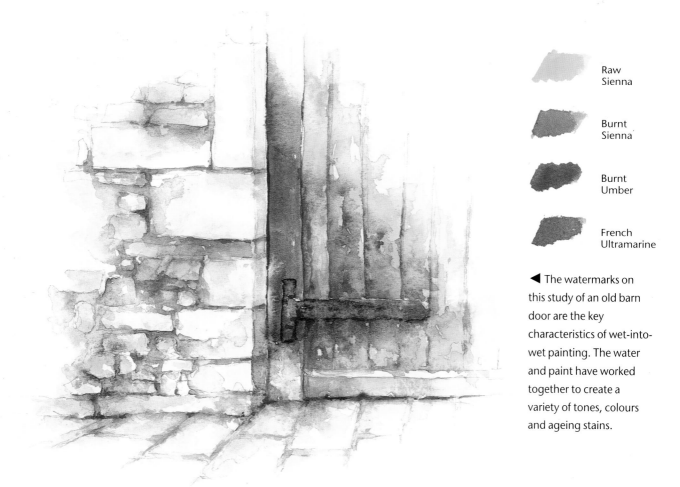

Raw Sienna

Burnt Sienna

Burnt Umber

French Ultramarine

◄ The watermarks on this study of an old barn door are the key characteristics of wet-into-wet painting. The water and paint have worked together to create a variety of tones, colours and ageing stains.

Spattering

The technique of spattering is a highly expressive method of applying texture to a painting, but it needs to be used selectively. You can easily overdo this technique and create a 'spotty' rather than a textured painting. Spattering is particularly effective when used on old stone walls, especially pitted concrete, or where areas of scrubland, pebbles or sand form the background to your building – and the more colours you use, the more effective it can look.

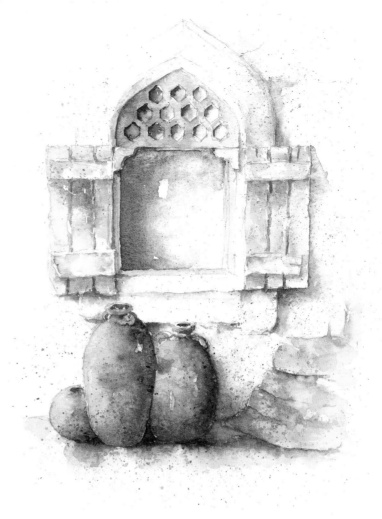

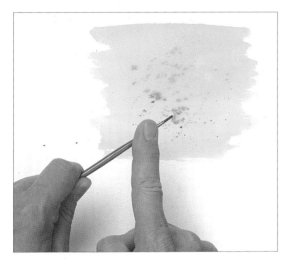

▲ Before you commit yourself to spattering a painting try the technique out on a scrap of paper.

▲ This shows the effect of spattering with one colour only. Raw Sienna was flicked on to a dry Raw Sienna wash.

▲ Notice the difference that adding another colour can make. Here Burnt Sienna was flicked on to a layer of Raw Sienna spattering and the result is a much stronger effect of texture.

For small paintings use a medium to small size watercolour brush. Dip this into a watery mixture of paint and position it quickly over the area you wish to spatter. Then tap the ferrule of the brush vigorously and rapidly. Small specks of watercolour paint will fly from the brush, spattering the paper. The closer to the paper you work, the more intense the effect, and the further away, the more spread out the texturing will be.

For larger paintings (A2 or larger) use an old toothbrush. Dip this into a small tray of watercolour paint, hold it bristles downwards at arm's length, and run your thumb along the length of the bristles. This, also, will flick the wet paint at your paper, creating a speckled effect very quickly. With a toothbrush you may find that the spatter is created in one direction. If this occurs, walk around your painting and spatter from different directions to counter this effect. Repeat the process with further colours if required.

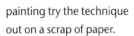

Coeruleum

French Ultramarine

Alizarin Crimson

Raw Sienna

Burnt Sienna

▲ **Moroccan Stone Building with Terracotta Pots**
23 x 15 cm (9 x 6 in)
This old, weather-beaten wall was textured by spattering with both the wall and shadow colour.

15

Understanding Colour

olour has always been a source of fascination to artists. It is colour that we so often remember when we try to recall scenes we have enjoyed, and it is colour that we see as soon as we open our paint sets. While there are some rules about using colour, it is considerably more fun to break them than follow them slavishly. However, before looking at specific paint colours it is helpful to consider some basic colour theory.

Complementary colours

A simple colour wheel can be formed with the primary hues red, yellow and blue. When pairs of these hues are mixed they form the secondary colours of orange, green and purple, and can be added to enlarge the wheel. Much twentieth-century painting is based upon the way in which colours that are opposite each other on the colour wheel react when placed side by side. These opposites are known as complementary colours.

Complementary colours will always enhance and visually push their 'partner' colours forward. They are best used, however, in small flashes. A yellow flower or Raw Sienna-coloured patch of stone viewed against a strong violet shadow can make your painting 'jump' with colour. Equally, a flash of scarlet geranium heads set against the strong green leaves and foliage of a hanging basket can make a vibrant subject for a painting. But to really make complementary colours work for you, they should be of similar strength. A pale, watery blue, for example, would have a very limited effect if placed next to a particularly powerful orange.

It is also useful to note that complementary colours make very good grey tones when mixed together.

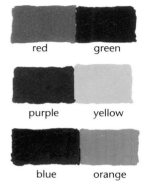

red green

purple yellow

blue orange

▲ Complementary colours sit physically opposite each other on the colour wheel.

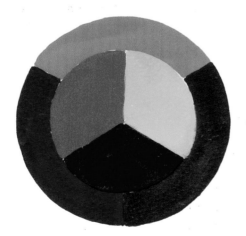

▲ The colour wheel, showing primary and secondary colours. The three primaries – red, yellow and blue – may be mixed to make secondary colours. Red and yellow give orange, yellow and blue produce green, while blue and red give purple.

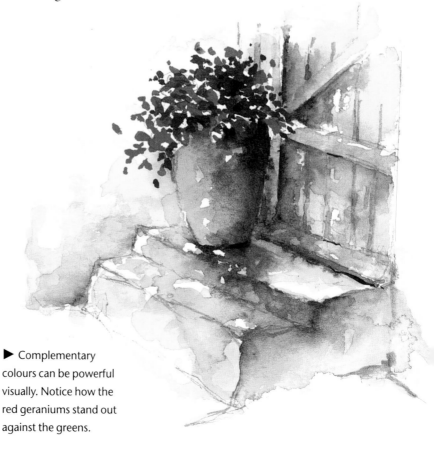

▶ Complementary colours can be powerful visually. Notice how the red geraniums stand out against the greens.

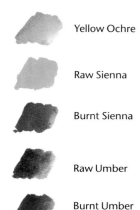

Yellow Ochre

Raw Sienna

Burnt Sienna

Raw Umber

Burnt Umber

▲ Natural earth colours.

Payne's Grey

Cobalt Blue

French Ultramarine

Alizarin Crimson

▲ These are the extra colours that I find invaluable for painting buildings.

Natural earth colours

The natural earth colours are of particular interest to painters who choose buildings as their subject. The pigments for these paints are dug directly from the ground – just as many of the actual building materials will have been. These pigments are usually siennas, ochres or umbers, and are dug from the mineral-rich seams of southern France and northern Italy. Raw Sienna and Burnt Sienna are both of particular value when painting buildings as they are ideal colours for brick and plaster.

Additional paint colours

While the natural earth colours will make up the majority of your palette, some additional paint colours will be invaluable. Cobalt Blue and French Ultramarine are particularly useful colours and can be used either to darken the natural earth colours, or to create sky mixtures and shadows. Alizarin Crimson is a particularly good paint to add to French Ultramarine when you wish to create warm shadows and shading. The violet created by this mix oozes with the damp, redolent heat of a summer's day.

For cooler, less animated shadows, use Payne's Grey. This is a blue-based grey, but it does contain black and will, therefore, 'flatten' your pictures, so use it sparingly!

Tones

The nature of the colours previously mentioned can all be changed either by mixing or diluting them – both actions will result in a different type of paint. When you mix two colours you will be able to allow one colour to dominate the mix, and by increasing or decreasing the quantity of this colour in the mix you can alter the tone while still maintaining a strong paint.

You can also alter the tone of any colour by diluting it. The more water you add, the lighter the tone will be.

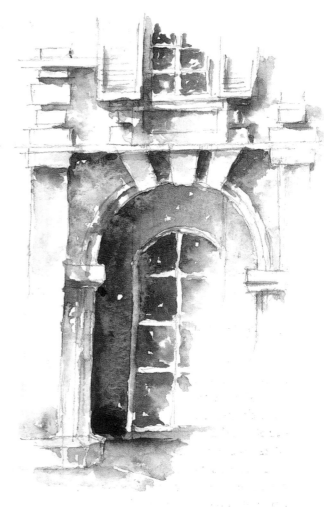

▲ Two or more colours mixed together will often result in a grey colour. It is a good discipline to make tonal studies of buildings to understand more of their structure.

▶ This shows the range of tones that can be created by mixing a neutral grey from Burnt Umber with Cobalt Blue without adding any other colour, but diluting the mix with water.

Burnt Umber + Cobalt Blue

▲ A neutral grey mix.

Warm and cold colours

Many colours are credited with holding a certain colour 'temperature'. This means that they impart a feeling of warmth or cold. Traditionally, blues have been considered to be cool colours, while oranges have been viewed as warmer colours. This theory is not, however, as straightforward as it might initially seem. Oranges and reds are, quite correctly, usually associated with heat and warmth. Yellows, however, are not quite so easy to categorize. Cadmium Yellow, for example, is a particularly warm colour, while Yellow Ochre, a natural earth colour, is usually considered to be a rather cool colour. Lemon Yellow is a colour that can veer either way: it can be used for the cool, sharp tones of spring meadow flowers surrounding buildings, or, alternatively, for a lemon tree viewed against the sienna colours of a Mediterranean stone farmhouse, glowing with the warmth of the summer sun.

Blues are also not necessarily all that they may seem. Cobalt Blue and Coeruleum are at the cool end of the scale, while French Ultramarine is a particularly warm colour

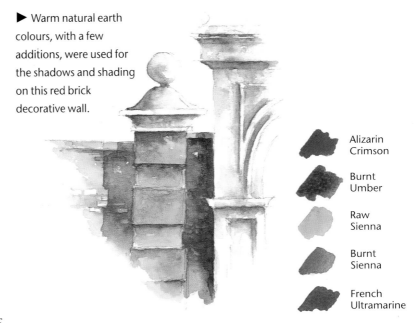

▶ Warm natural earth colours, with a few additions, were used for the shadows and shading on this red brick decorative wall.

Alizarin Crimson

Burnt Umber

Raw Sienna

Burnt Sienna

French Ultramarine

and can always be relied upon to add a little heat to shadows.

Violets and mauves are chameleon colours, and can provide a whole range of colour temperatures, depending on the particular colours used to mix them. Cobalt Blue and a small amount of Cadmium Red, for example, will give a fairly cool violet for those soft, early morning shadows, whereas French Ultramarine and Alizarin Crimson will provide a rich, warm purple colour that is ideal for painting the long hot shadows of a summer's afternoon.

Most of the natural earth colours hold warm qualities. This is not surprising as they have their origins in the warm soil of the Mediterranean landscape. Raw Sienna and Burnt Sienna are particularly warm colours and are often used to underpin paintings by being applied as a first wash. All other colours painted over this wash will be visually influenced by the colour temperature of these paints. Burnt Umber also holds similar qualities, but is a little too rich to be used as an underwash. Raw Umber, however, is a very different paint, being a cool olive colour.

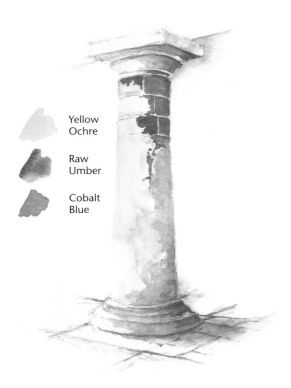

Yellow Ochre

Raw Umber

Cobalt Blue

◀ A mixture of cool-coloured natural earth paints and a little Cobalt Blue was used to create the shadows on this old stone pillar.

◄ **Stone Farmhouse**
23 x 15 cm (9 x 6 in)
The soft, warm Raw
Sienna stone of the
old farmhouse is
complemented by the
sharp, angular violet
shadows.

Light and Shade

We see the three-dimensional world around us as a direct result of light and its consequence – shade. The way in which light bounces from buildings, and the way in which shadows are cast across parts of the built environment, can be represented on a flat surface such as watercolour paper with just a little practice and observation.

Shadows

Shadows are particularly important to artists wishing to paint buildings. The shadows of buildings help to define the shapes of their facets and make them more clearly visible. Doorways, window frames, balconies, and so on, are all made sharper and defined more clearly by shadows. The dark areas appear to thrust any outstanding features forwards, emphasizing their structure and specific architectural character.

The angular nature of shadows cast by buildings can be of particular interest to the artist. As these shadows fall across other buildings they impose a new order onto the structure, casting deep shadows across solid walls and creating hard angular shapes and patterns. Equally, the shadows from buildings that are cast onto the ground close by can be just as visually interesting with their angles and variety of shapes.

Painting shadows on to buildings must not be a laboured activity. They are best applied in one quick, confident brushstroke using a single wash. The translucent qualities of the shadow wash will allow the paint underneath to show through when it dries. Do not attempt to blend the paints together physically on the surface of the paper as this will reconstitute the surface of the paint of the building, muddying the shadow colours and destroying their clarity.

▼ Hard, angular shadows can give buildings an added sense of structure as the dark areas visually push the lighter areas forward.

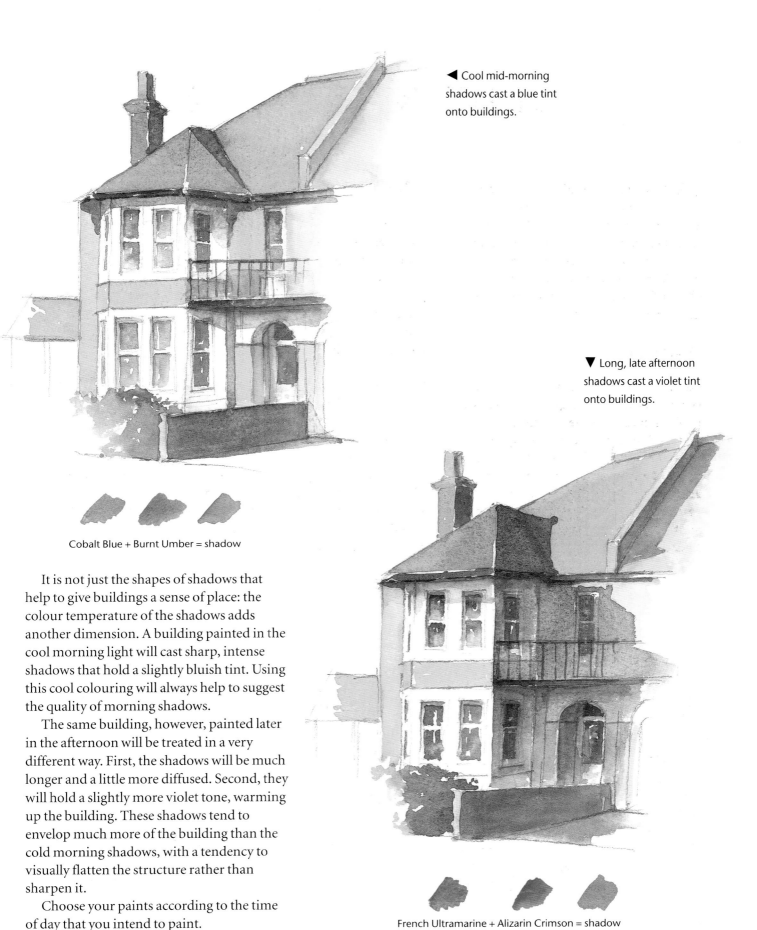

◄ Cool mid-morning shadows cast a blue tint onto buildings.

▼ Long, late afternoon shadows cast a violet tint onto buildings.

Cobalt Blue + Burnt Umber = shadow

It is not just the shapes of shadows that help to give buildings a sense of place: the colour temperature of the shadows adds another dimension. A building painted in the cool morning light will cast sharp, intense shadows that hold a slightly bluish tint. Using this cool colouring will always help to suggest the quality of morning shadows.

The same building, however, painted later in the afternoon will be treated in a very different way. First, the shadows will be much longer and a little more diffused. Second, they will hold a slightly more violet tone, warming up the building. These shadows tend to envelop much more of the building than the cold morning shadows, with a tendency to visually flatten the structure rather than sharpen it.

Choose your paints according to the time of day that you intend to paint.

French Ultramarine + Alizarin Crimson = shadow

21

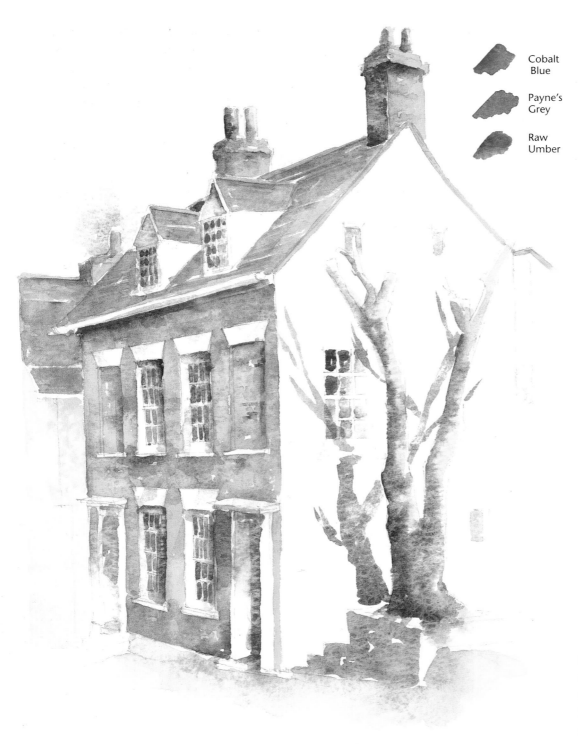

Cobalt
Blue

Payne's
Grey

Raw
Umber

◀ The coolness of the
hard-edged shadow cast
onto a plain white wall
emphasizes both the cold
light of the season and the
time of day.

Seasonal changes

While the particular time of day will affect
both the intensity and colour temperature of
the shadows cast on your building, so too
will the particular season. The colour
temperature of the seasons also has a marked

effect on the way on which you will see and
paint buildings.

Winter and spring are renowned for their
cool, short days and even longer nights. While
the colour temperature and general quality of
the light will still change during the day, blues
will predominate throughout. Cobalt Blue or

Coeruleum best suits these seasons. Shadows are also best created with a cool blue base that may be enhanced even more with a little Payne's Grey and a touch of the colour that is casting the shadow. At this time of the year most shadows will be cast by other buildings or leafless, skeletal trees. It is important to ensure that shadows cast on to, or from, buildings are tinted with the colours of the immediately surrounding objects. The light that is bouncing from the surrounding objects picks up reflected light from every surface. To make your paintings look realistic you need to do the same. A mixture of blues, Payne's Grey and a touch of Burnt Umber or Raw Sienna will produce shadows that appear to be part of the scene and not just extras added on as an afterthought.

Equally, the soft, warm violet shadows created by the summer sun are different in their mixtures and appearance, but not in the way in which they are used. French Ultramarine and Alizarin Crimson are ideal mixtures, but these will also benefit from the addition of a hint of the green used for the bulk of the trees that are much more likely to be in full bloom at this time of year. This will help give unity to the painting.

▼ Soft, hazy shadows cast across this building and the foreground indicate the warmth of a lazy summer day.

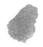 French Ultramarine

 Alizarin Crimson

 Raw Sienna

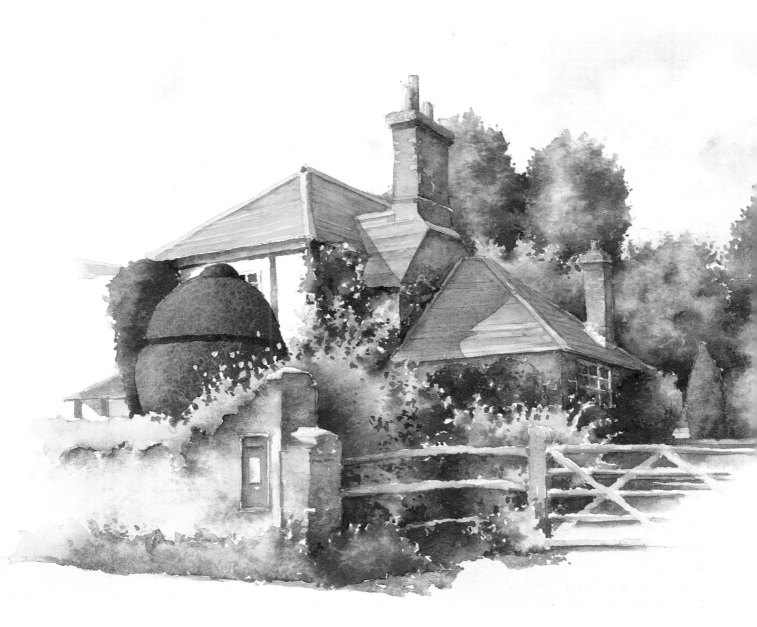

Simple Perspective

One particular task for any artist starting to paint a picture is to consider how to translate the three-dimensional world onto a physically flat two-dimensional surface. Perspective is a system developed by artists that allows you to do this convincingly. The word 'perspective' all too frequently strikes fear into the hearts of beginners – but it really does not need to be frightening, or even desperately difficult, so long as you remember a few basic rules.

One-point perspective

Architects and draughtsmen tend to adopt a tightly regulated approach to perspective, but artists can afford to be a little less rigid in their rendering of buildings. It is important to bear in mind that you are following a system, and you will often be inventing, imagining or creating lines and shapes that you cannot actually see, but are necessary for working out the correct perspective.

One-point perspective is used when you are viewing a subject such as a long terrace. As you look in one direction along the length of the terrace the buildings will appear to be smaller at the furthest end; they probably will not be smaller, in fact, but this is the illusion to record. When you make your preliminary drawing make sure that the top line of the building and the bottom line of the building

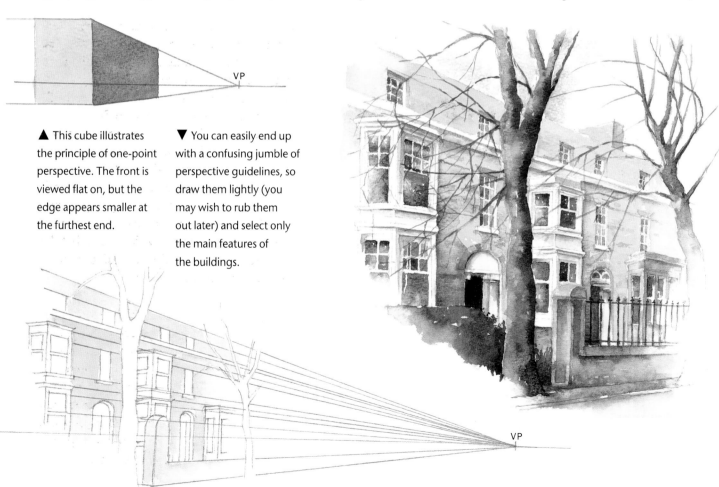

VP

▲ This cube illustrates the principle of one-point perspective. The front is viewed flat on, but the edge appears smaller at the furthest end.

▼ You can easily end up with a confusing jumble of perspective guidelines, so draw them lightly (you may wish to rub them out later) and select only the main features of the buildings.

▼ **Autumnal Terrace**
25 x 23 cm (10 x 9 in)
Having established the perspective, this building was painted using cool blues and grey shadows to indicate the time of year.

VP

24

converge to a point in the distance on the horizon. This point is known as the Vanishing Point; it does not exist in reality, but is part of the system of perspective. Every time you need to draw the top or bottom of any particular feature, such as the line of windows within the terrace, make sure that you draw guidelines to the vanishing point to ensure that these features recede in scale.

Two-point perspective

Two-point perspective employs the same principles as one-point perspective, only the cube from which buildings are constructed has both visible sides appearing to recede to vanishing points on the horizon.

This system of recording buildings is best employed when you can clearly see both the front and side of a building, viewing the scene from the corner. In this situation all of the facets (such as windows, doors and

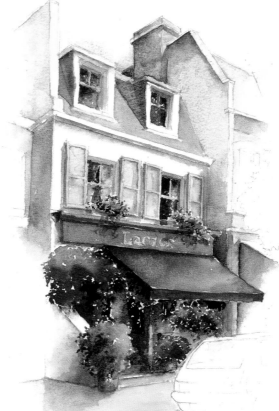

◀ **City Shop**
30 x 20 cm (12 x 8 in)
This small building sandwiched between two larger ones, with its dormer windows and awning, was ideal for practising two-point perspective.

architrave) on the right of the corner will appear to converge along the perspective lines drawn to the vanishing point on an often imaginary horizon at the far right of your composition. Exactly the same principle will be applied to the left-hand side of the building, with all lines appearing to meet at a point on the horizon. It is essential that both vanishing points are established on one horizon line only or the system will not work.

On a sunny, well-lit day your perspective will allow you to paint the shadows onto your buildings with greater ease, knowing that the solid blocks of the building are established in line form for you to work on to.

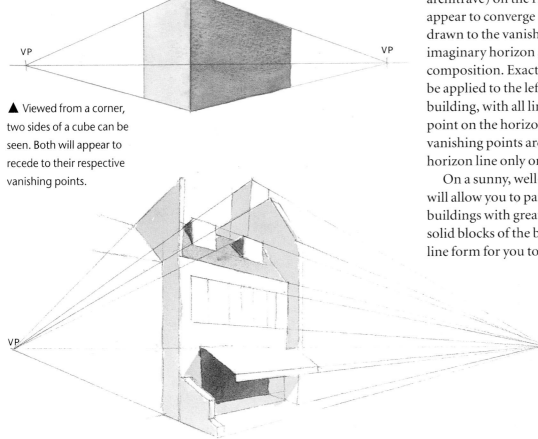

VP — VP

▲ Viewed from a corner, two sides of a cube can be seen. Both will appear to recede to their respective vanishing points.

VP — VP

◀ To establish a two-point perspective drawing you may occasionally have to imagine one vanishing point off the paper, or you can place a sheet of scrap paper at the edge and extend your lines on to that.

Box construction

Having developed confidence in using perspective systems, you will find that nearly all buildings can be constructed with the aid of boxes and cubes drawn in perspective. By seeing your subject as a simple box or cube underneath its elaborate structures you will soon learn to build up solid shape and form, and you can add box or cube shapes in the appropriate places as you develop your picture.

This construction system will also help you to both understand and see where the shadows will be. Should you need to construct a porch 'box' on the front of a building, you will soon see that it juts out from the main structure and will, therefore, cast a shadow. The solidity of shadows and shading can also be established more easily once the box construction process is complete.

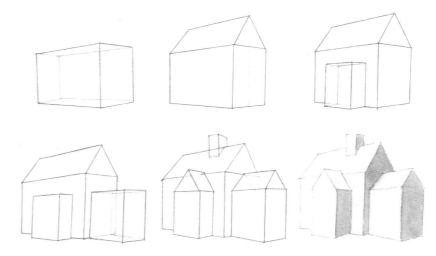

It is important to bear in mind, however, that this is a system for constructing a framework on which to paint. Do not get so carried away with the drawing that you lose sight of the tones, colours and textures of your subject. Draw the framework of boxes lightly as you will want to remove some lines.

▲ This system involves sketching a box for the main structure, and adding more box units as you need them.

▲ Adding tone to the box construction will help you to view the separate boxes as linked elements of a solid three-dimensional building.

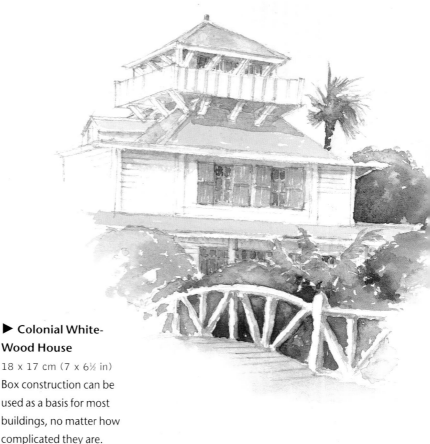

▶ **Colonial White-Wood House**
18 x 17 cm (7 x 6½ in)
Box construction can be used as a basis for most buildings, no matter how complicated they are.

Arches in perspective

Some of the most appealing of buildings are either supported by, or visible through, arches. Old abbey cloisters, university and college walkways, and many similar structures contain a wide selection of arches to be sketched and painted, often in quiet and tranquil environments.

Arches viewed straight on are fairly easy to construct. A full circle with straight lines drawn down from the outer edges of the circle is all that is required. With these few lines established you can then concentrate on the task of mixing the appropriate paints and washing these around the shape of the arch. To draw and paint an arch in perspective you need to draw the circle in perspective to create an ellipse, and once again you simply extend the vertical lines from the outer edges of the ellipse. This will, however, introduce a new element into your picture as the inner and upper parts of the arch will now become exposed, producing an angled three-dimensional appearance.

Again, if drawn in a long row these ellipses will all appear to grow smaller towards the end of the buildings. As the angles become sharper, the arches appear to be tighter together and less space will be visible through them.

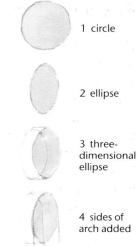

1 circle

2 ellipse

3 three-dimensional ellipse

4 sides of arch added

▼ **College Cloisters**
20 x 20 cm (8 x 8 in)
The ornamental detail on these arches – ridges and carvings – make them even more interesting because of the highlights and subtle shadows.

▲ The stages of constructing a three-dimensional ellipse, which, with the addition of paint, becomes an arch.

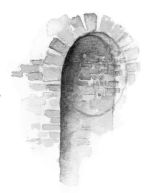

front view

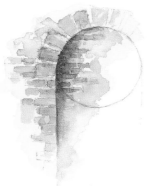

angled view

▲ To construct an arch from an angle simply imagine twisting a round coin from a front-on view to a slightly angled view. This process will help you understand the structure of the actual arch.

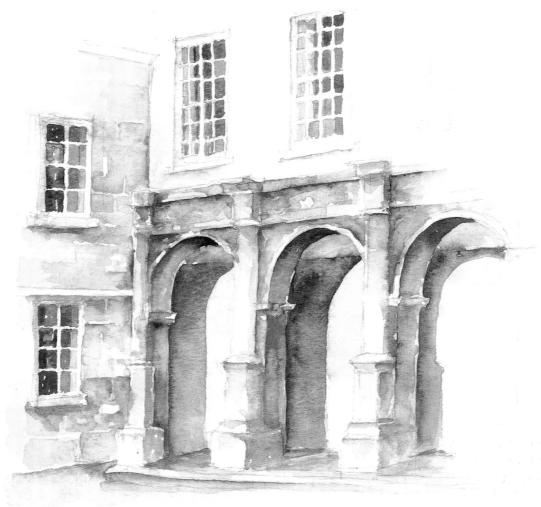

Composition

When we look at a subject that we find particularly appealing to paint we are looking with fairly wide-angle vision. Often this will need to be narrowed down to fit onto a rectangular sheet of paper. So an element of selection becomes involved and we have to make decisions about exactly what to place where on our paper.

Choosing your viewpoint

Having found an interesting building to paint, it is important to make one particular decision from the beginning: what angle are you going to paint it from? Some environments offer little choice. These are usually in towns or cities where buildings are so close together that you can often only see the front. Rural buildings, however, tend to have more space around them, allowing you to choose your viewpoint.

On a bright, sunlit day you will often find that one side of a building is cast in shadow. If you choose to position yourself with such a side facing you, your picture may contain some good contrasts between the side that is receiving the full glare of the sun and the wall that is being darkened by shadow. Such a view will usually produce the most pleasing compositions as any angle on a building that is emphasized by the contrast of light and shade will add a dynamic element to a picture. The main disadvantage is that much of the foreground will also be cast in the shade, resulting in your having to flood the area in which, traditionally, we find detail, with a dark wash that can flatten any detailed painting. While this flattening effect can be minimized by the use of colour in shadows, it can never be removed completely as this is the very nature of shadows -- they remove the highlights and the 'sparkle'.

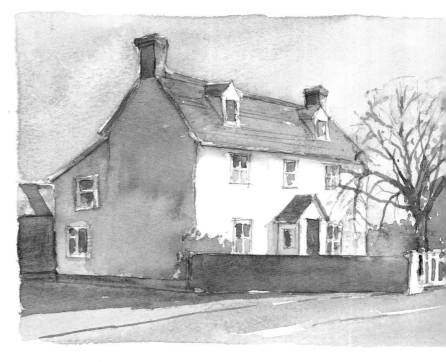

▲ Painting a subject facing the light can produce a dramatic composition, but can be hard on the eyes.

Another option is to paint your chosen building face on. This view has the advantage that you do not need to worry about perspective. The windows and doors, for example, will appear as straightforward geometric shapes – squares or rectangles. Unfortunately, in such views many of the key features will not have shadows to help you to define them in paint. Unless your building is surrounded by other large shapes that cast shadows across your subject, the composition could look a little 'boxy' and static.

A final option might be to work with the sun behind you. Shadows from your subject will be cast away from you. This will provide a very light picture with only a few dark areas on the far side of your building.

It is always a good idea to make a few quick thumbnail sketches of your building from a couple of different viewpoints prior to starting a large composition. This will inevitably save time in the long run.

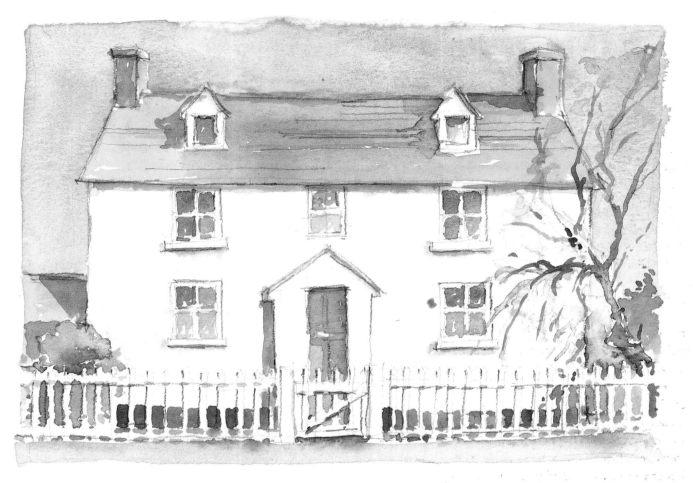

▲ A 'front-on' view can produce an architecturally accurate composition, but can be visually rather flat.

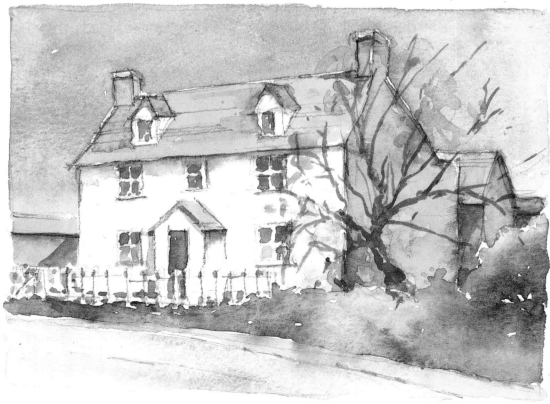

◄ A composition with the light behind you will produce a 'high key' painting that brings into focus a variety of elements.

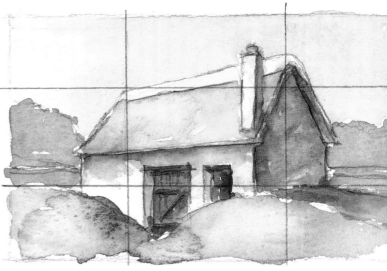

▲ In a close-up view the building will dominate your picture, requiring you to concentrate on its fabric and features.

▼ A wide-angle view will allow you to record much more of the immediate environment, so putting your building into context.

Placing your subject

Having chosen your subject, considered the direction of the light and the most suitable angle from which you wish to paint your building, you should next consider exactly where you are going to place your building on the paper. You might wish to 'zoom in' on your subject and create a close-up picture of the building that almost fills the whole sheet, or you may choose to take a wide-angle view where much of the surroundings can be included either side of your building as well as the sky and foreground.

▲ According to accepted artistic theory, a good composition can be achieved by placing elements on a picture plane divided into thirds.

Traditionally, artists have used the convention of visually dividing their picture surface into thirds to help them to plan their compositions. If the main features of the building, such as corners, chimney pots, and so on, fit along or near these lines, then the composition will usually appear to be fairly well balanced. Using this method it is unlikely that any major element would be placed in the geometric centre of the picture

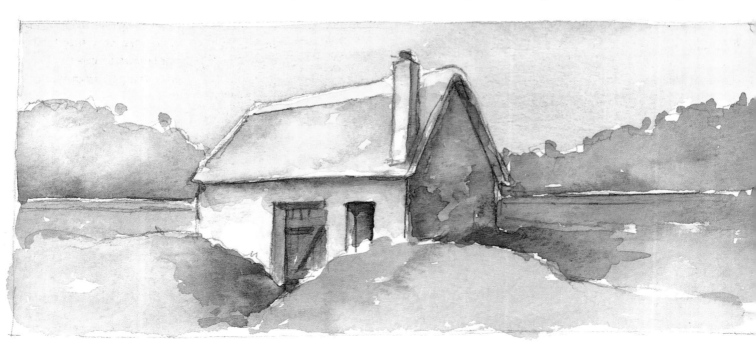

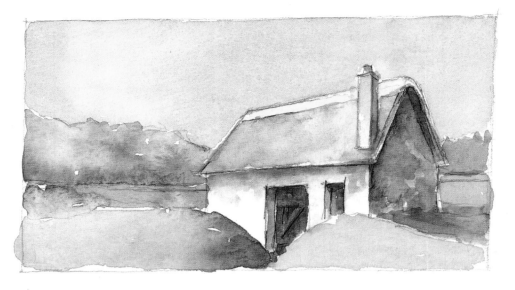

◄ Placing a building off centre can give added interest to a composition as the viewer is not certain exactly what to look at, so the eye moves around the picture plane.

where it might unintentionally become the centre of focus.

It is always a good idea to avoid placing a facet of the building in the very centre of the paper as this will become the first thing that the eye will be drawn to and, as a result, the quality of painting in other parts of the picture may go unnoticed.

Equally, it is best not to place a horizon line in the centre of the page as this will have a similar effect. Placing your horizon line on or near the lower third will allow you to paint a building as part of its natural environment with a large expanse of sky showing. This will often involve more shadows being cast. It is important when painting these scenes with dominant skies that you use your main sky colour to mix the shadows on the ground. This will help to unify the picture, ensuring that the sky, ground and building all look as if they are part of the same scene and not cut out and stuck on.

Of course, it is always a good idea to experiment with different compositions before making a final decision. Try placing your subject off centre, to the left or right, top or bottom, to see exactly what sort of effect you can create.

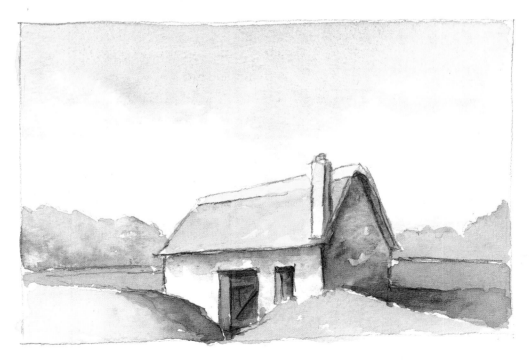

◄ Allowing a sky to dominate a composition can be used to create a very atmospheric picture.

Textures

The natural types of building materials to be found around the world vary little, with stone, brick, wood and glass being by far the most commonly found, but they provide a wealth of different textures. Watercolour paints are probably the paint media most suited to recording textures. The granular qualities of the paints and the rough surface of some watercolour papers combine particularly well to suggest many of the textures of brick, stone and wood.

Brick, stone and wood

Brick has a fairly universal texture, but noticeable variations can be seen between new bricks and old, weatherworn crumbling brickwork. Different types of stone are used in a number of forms with an accompanying variety of textures. The smooth round cobbles traditionally used to construct seaside cottages contrast with the sharp flint stone houses of quarry workers, while sandstone has a different texture to both.

Wood takes on a weathered appearance as it ages. New, freshly painted woodwork gives off a sheen, whereas old, sun-bleached or splintered wood can look dull and lifeless.

To create textures within the fabric of buildings you need to be prepared to use a lot of water and to have the patience not to intervene too early. Wet-into-wet or wet-into-damp techniques are mainly used for producing texture in watercolour and it is all too easy to counteract many of the effects that these techniques give.

Most textures start with an underwash, often of Raw Sienna. This is especially the case with brick, concrete or stone, but also frequently applicable to older, faded woodwork. You might find that older, rougher textured surfaces are best recorded by blotting the underwash with a piece of

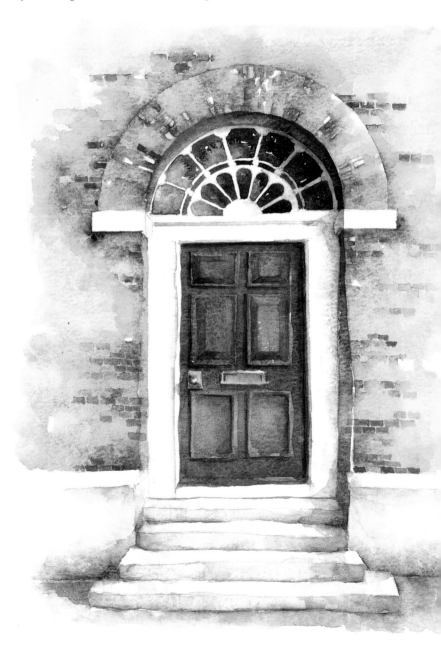

▶ **Decorative Brickwork**
33 x 22 cm (13 x 8½ in)
The textures of brickwork can even be varied within one particular building, so look carefully at the nuances in your subject.

► Blot the underwash to create 'sparkle', then apply wet paint around this. When dry, 'draw' in brick shapes with paint.

scrunched up kitchen paper. This creates a small dry section amongst the damp fibres of the paper. If you apply another colour at this stage you will achieve both a bleed and a hard edge, which is ideal for suggesting texture. Other colours can be applied in rapid succession to achieve a greater variety of tone.

▼ **Stone Wall Textures**
22 x 28 cm (8 x 11 in)
Stone walls reflect light, and throw strong shadows, so are perfect for washing and blotting.

Glass

Painting glass, however, is a little different. As glass holds no colour of its own, the only way that we can actually see it is by observing the colours that it reflects. The light that is reflected is equally as important and, in watercolour painting, this is best captured by leaving the paper plain white to represent little flashes of pure light. To avoid the colours reflected from glass becoming muddied it is particularly important that the window panes of a building are treated to a one-stroke technique. Work onto dry paper with a medium size brush loaded mainly with the sky colour and apply the paint using broken brushstrokes to allow those all-important flashes of white paper to work for you.

Remember, too, that even glass can be quite visually flat and non-reflective on occasions. For less reflective glass in dull light, leave fewer white 'flashes'.

► Lots of water and two paints only – Raw Sienna and Burnt Umber – were all that were required for this study of an old wooden door.

▲ French Ultramarine and Burnt Umber are good colours to mix to paint reflections from glass. Always work onto dry paper with broken brushstrokes, picking out any specific reflections and leaving those shapes white as well.

Out and About

Sooner or later you will want to venture out to start working 'on site'. Rarely do we get the opportunity to set up our easels and paint in any environment for a particularly long period. The weather, builders, delivery trucks and window cleaners seem to conspire against us, blocking our view or forcing us to run for cover. For this reason a sketchbook is a very valuable tool.

Sketchbooks

Watercolour paints are the ideal medium to use with a sketchbook as they are light, small and quick to dry. This will enable you to paint several different sites during the course of a day. Most watercolour pads hold 300 gsm (140 lb) paper. This is quite thin paper and is not designed to stand up to a lot of watery washes. However, the essence of making sketches is that they are quick responses to a subject and do not need to be laboured over.

Sketchbooks can hold a record of a personal journey or holiday that can be kept forever, or they can be seen as reminders to aid your visual memory when you return home and wish to paint a more elaborate version of a sketch. A sketchbook allows you to make a variety of useful visual notes – pencil sketches or quick watercolour sketches of buildings, or even individual studies of specific architectural details.

The next few pages are concerned with how best to record the individual elements that go to make up buildings but are not often viewed in isolation.

▼ This sketchbook study has only been treated to a light wash, using a watercolour pan set and one brush only.

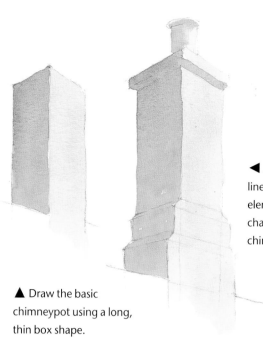

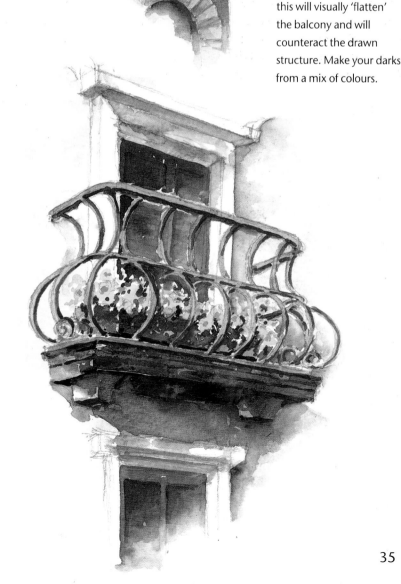

◄ Adding the protruding lines of the decorative elements starts giving character to the chimneypot.

▲ Draw the basic chimneypot using a long, thin box shape.

◄ Painting 'positive' and 'negative' bricks adds textural interest to a chimneypot study.

▼ The underside of a balcony will be the darkest area to paint, but do not be tempted to use black as this will visually 'flatten' the balcony and will counteract the drawn structure. Make your darks from a mix of colours.

Looking up

So often when we travel around rural and urban roads we look straight ahead with our eyes fixed firmly on the subjects in front of us. But sometimes it is a good idea to look up above your natural eyeline to find some of the architectural details such as chimneypots, balconies, decorative plaques and so on that can give buildings so much personal and unique character.

Chimneypots are best recorded using the box construction method. First draw the main vertical lines, making sure that they are parallel. If you work from a photograph you will find that a certain amount of distortion has taken place, but as an artist you can correct this. Then add the details to the box. Most chimneypots are made of brick, so use Raw Sienna for the first underwash, followed by Burnt Sienna and Burnt Umber, picking out a few individual bricks for detail.

Balconies can be constructed in a similar way. The key characteristic of balconies, however, is the shadows cast by them. As you look up from ground level you will see the underside of the balcony – this will always be dark – and because the light will come from the sky, the shadows will always be cast downwards. These shadows are best painted on to dry paper to allow for sharp definition of their shape.

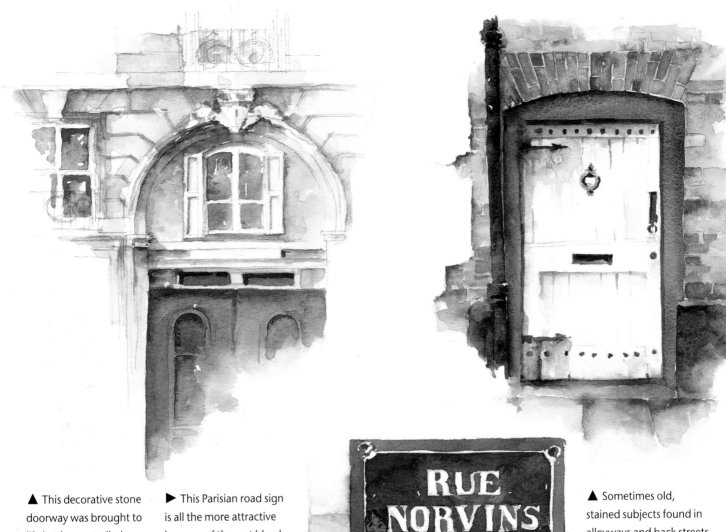

▲ This decorative stone doorway was brought to life by the controlled use of shadows, at first almost drawn on with a small brush and little water.

▶ This Parisian road sign is all the more attractive because of the rust bleeds from the enamel onto the brick. The change in colour was achieved by working wet-into-wet.

▲ Sometimes old, stained subjects found in alleyways and back streets can be attractive. The decorative brickwork and shadows make this rickety old door more compelling to observe and paint.

Looking ahead

While buildings with their own structural identities are exciting to paint, sometimes it can be more fun to seek the individual elements that go to make up a particular building. At eye level you will find an assortment of decorative doorways, windows and functional signs adorning walls.

Doorways and window frames are nearly always set back into the fabric of the wall and, therefore, have a shadow cast from the wall. You may often be attracted by the decorative stone or brickwork that surrounds the door or window. When painting these facets it is best to use a small brush to run a line of the shadow colour directly under the protruding brick or stone and then, using plain water, pull the paint downwards along the line of the window or door frame. This will have the effect of gradually diluting the paint, reducing its strength of colour as it is pulled away from the top. So, as with the object, the darkest shadows will be at the top, directly underneath the stone or brick, and the lightest shadows at the base.

Looking down

Sometimes as you walk through urban districts it can be interesting to cast your eyes downwards into the bays and stairwells that often accompany the basements of houses.

It is worth spending some time on the construction stage when drawing basements. Try to imagine the steps leading downwards from road level as being transparent. Like the box construction system, this will help you to understand not just how the steps descend, but also to achieve a sense of proportion and perspective in your drawing. Also, unlike most other views of buildings, the perspective lines of the other features such as windows, doors and so on will appear to run down towards the bottom corners of the paper, allowing you to see the tops of window frames and doorways.

Usually, the shadows that help to define the shapes and angles of basements will be painted diagonally across the page. In addition, the bulk of the shadows (the deepest tones of your shadow colour) will accumulate at the bottom where the light can least penetrate.

Complete the steps by leaving a 'flash' of either the underwash, or just pure white paper, showing through on their very edge, followed by a shadow directly underneath the step. This will visually punctuate the difference between the levels of the steps.

Painting looking down into a basement may involve reversing your normal approach.

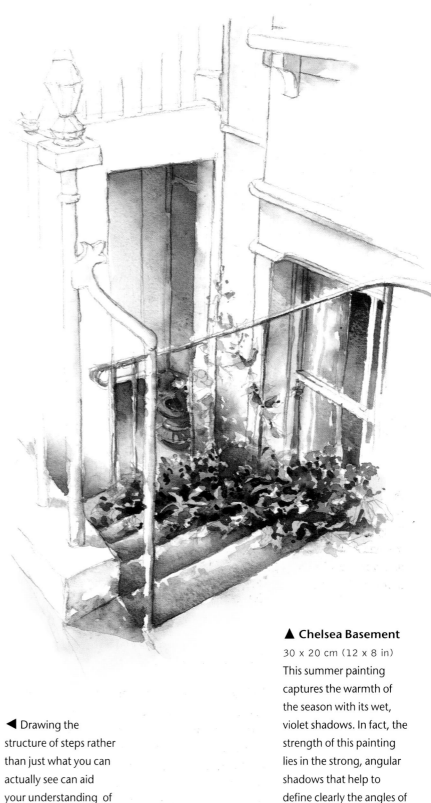

▲ **Chelsea Basement**
30 x 20 cm (12 x 8 in)
This summer painting captures the warmth of the season with its wet, violet shadows. In fact, the strength of this painting lies in the strong, angular shadows that help to define clearly the angles of the steps.

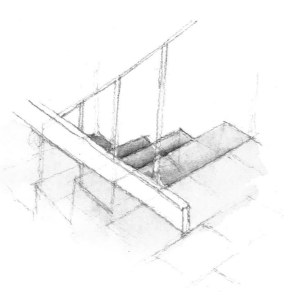

◄ Drawing the structure of steps rather than just what you can actually see can aid your understanding of the subject and will help you to decide exactly where to put the shadows.

Country Buildings

A trip outside the urban environment to find some of the delightful older, rambling buildings so often found in the countryside is a true pleasure. Here you will find that skies and background dominate the composition in a way that cannot possibly happen in built-up towns and cities.

Skies

Buildings cannot exist in isolation: they are all situated on a surface with other buildings and, even if on their own, are surrounded by space. This space can take on a particularly important role when painting buildings. It is the sky, for example, that determines both the colour and the type of shadows. A clear blue sky will result in strong, often hard-edged shadows with a hint of violet (mixed with the blue used for the sky), whereas a muted, grey sky will result in flat, soft shadows, often made up of neutral greys.

While you will probably not want your sky to become the main area of focus in your composition – your building should be that – you can use it to enliven a scene. It is best to use a lot of water in skies as this will help to maintain an even flow of paint. For plain clear skies apply an initial wash of water. Then load a large brush with your sky colour and, starting at the top, wash the paint horizontally across the paper. The paint will run downwards on the damp paper, diluting as it runs towards the horizon. To create clouds, use the same technique, but blot out the cloud shapes with a piece of kitchen paper, adding a touch of Raw Sienna to the clouds to prevent them appearing all white. For stormy skies use the same technique again, but use greys and browns and do not be afraid to manipulate the wet paint with a brush to create a sense of movement.

◀ Clear sky
A mixture of warm French Ultramarine and the cooler Cobalt Blue provides a good balance of tone for this sky study.

Cobalt Blue French Ultramarine

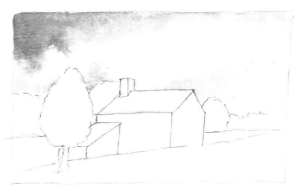

◀ Cloudy sky
A touch of Raw Sienna added to the base of damp clouds prevents them from looking like flat, two-dimensional shapes. Using this tiny amount of colour also adds tone.

Cobalt Blue French Ultramarine Raw Sienna

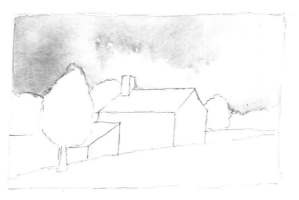

◀ Stormy sky
Payne's Grey and Burnt Umber produce a strong, stormy grey, but you will still need a touch of blue to maintain a natural appearance in skies.

 French Ultramarine Payne's Grey Burnt Umber

Relative distances

The landscape in which a building is set will also form an important part of the composition. For artistic purposes it is convenient to break this down into three (albeit not always clearly defined) sections: the background, the middle ground and the foreground.

Since the particles suspended in the atmosphere tend to reflect more blue light than any other colour of the spectrum, distant scenes and furthest backgrounds will nearly always take on a bluish tint. For this reason it is usually a good idea to mix any background trees, hills or fields by starting with the sky colour and adding a hint of green to that, rather than starting with the green and then adding the blue.

The middle ground is, as it suggests, the area between the background and the foreground. This section of the composition will not hold any strong colour or particular level of detail. While the middle ground is often mixed with a hint of blue, it will not be the dominant colour as this section will simply establish the ground or area behind the building.

The foreground, however, will capture the strongest of colours and tones, and will be the most detailed section of the composition – except for the building.

▲ If you paint the background and middle ground first, you will develop a clearer sense of the strength of colour required to paint the building. This will, in turn, help you to establish the foreground.

▼ Sometimes it pays to make a few quick sketchbook studies of the objects surrounding buildings – such as trees.

BACKGROUND COLOURS

Sap Green Cobalt Blue

MIDDLE GROUND COLOURS

Sap Green Raw Sienna Cobalt Blue

FOREGROUND COLOURS

Sap Green Cadmium Yellow

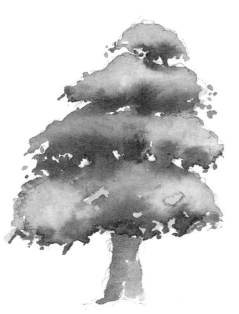

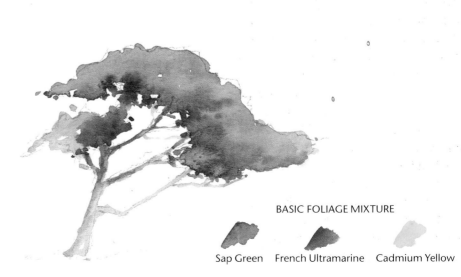

BASIC FOLIAGE MIXTURE

Sap Green French Ultramarine Cadmium Yellow

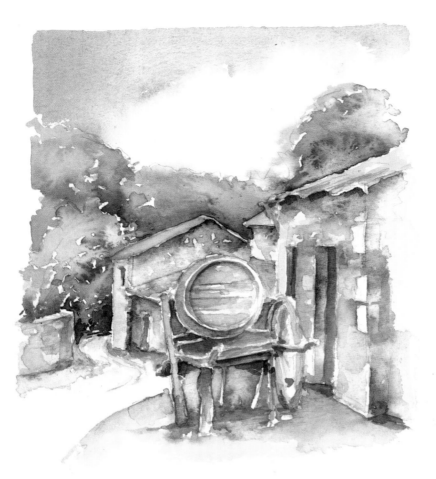

▲ Farm Buildings

20 x 17 cm (8 x 7 in)
These old stone farm
buildings were painted
using wet-into-wet
technique to achieve
the texture and tones of
the fabric of the barns
and stables.

Farm buildings and cottages

The beauty of painting buildings in the rural environment of any country is that you are nearly always surrounded by space and will be able to find a suitable spot to set out your equipment and paint. While it is unlikely that your view will be spoilt by delivery vans or a constant stream of traffic, villages are often working places and tractors and herds of cattle do move about, so check your site for potential signs of activity.

Most country buildings are surrounded by greenery of some sort – either trees or tall garden plants and shrubs. Unlike urban buildings, you will often not see the whole of a country building as much of it may be obscured by trees and bushes. These features must become part of the scene and not simply added on at the end. To make them look as if they are part of the building's setting, mix the colours using the same blue as used for the

sky. Apply the green mixture to damp paper as this will produce some soft bleeds. As this begins to dry, a darker version can be mixed, adding more blue, and applied to the shaded side of bushes, the undersides of clumps of foliage on trees, or where shrubs can be seen through gates and so on. When this has dried it will give a light and medium tone tree or bush – remember that watercolour paint dries lighter than it appears when wet. The darkest tones are achieved by applying a dark mix using a small brush to 'dot' shadows onto dry paper. French Ultramarine, Sap Green and a touch of Burnt Umber works well for a dark foliage colour.

Owing to its translucent qualities, watercolour paint cannot effectively be used to put light paint on top of dark paint. So, if you wish to paint the riot of colour that is often found in the flower gardens of country buildings you need to consider this from the very beginning. Any areas of bright colour need to be painted first, and the greenery painted around them.

Alternatively, the areas of colour may be left as plain paper and the bush of leaf colours painted around these spaces. This method allows you to achieve a more fluid appearance in your painting, as the paint can still be applied to damp paper and allowed to bleed. The key is to leave the flower areas dry since watercolour paint will not readily run onto dry paper. Then, when you have created the washes to represent blocks of leaves and shrubs, you can use a small brush to dot in the flower colours and, again, the deepest shadows to offset the brightness of the oranges and reds of country garden blooms.

► Cottage Garden

15 x 22 cm (6 x 8½ in)
The intensity of the colours in the front garden of this cottage provide visual flashes in the foreground, but possibly more important are the small flecks of white paper left to act as highlights. These add sparkle to the scene.

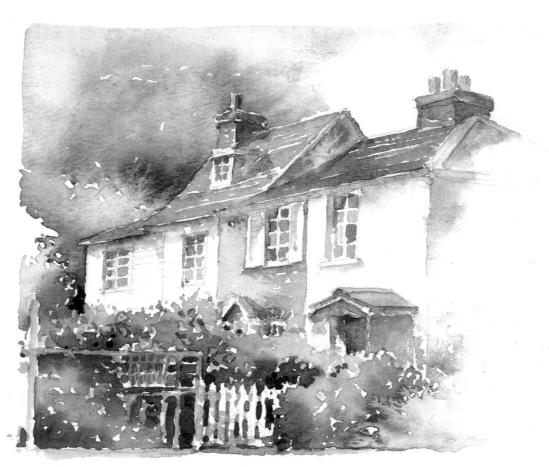

◀ **Group of Cottages**
17 x 19 cm (6½ x 7½ in)
The white of these
cottages was visually
'sandwiched' between
trees at the top and
bushes at the base, so
more attention had to be
paid to the colour balance
of these features than to
the buildings themselves.

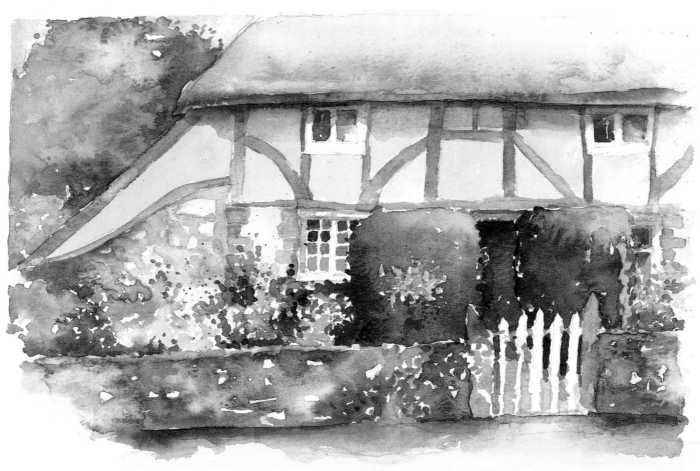

► If you draw the branches using masking fluid you will be able to paint the stone colours of the church directly over the top. When the paper is completely dry, remove the masking fluid to reveal a negative grid.

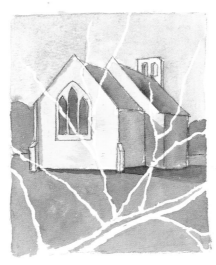

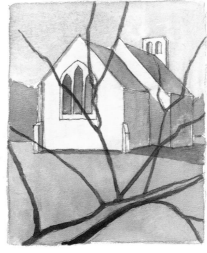

◄ Paint the foreground tree branches in a darker tone to increase the feeling of depth and space within the composition.

▼ **Churchyard in the Spring**
28 x 20 cm (11 x 8 in)
This painting uses both positive and negative shaped branches in the foreground to increase the visual interest.

Churches

Not all the buildings that you wish to paint will be surrounded by attractive green foliage, especially towards the end of the year as the leaves fall and the skeletal shapes of tree trunks and branches are all that remain. Equally, spring can be an exciting time to paint as green shoots and buds are just starting to form on trees.

Churchyards nearly always contain trees, and you will often be able to use these as an aid to composition. Because of the size of many churches (even the smallest are usually larger than a domestic house), you will need to position yourself a fair way back to see the entire building and this presents you with a compositional problem: how do you paint the increased amount of space that now makes up the foreground?

One particularly useful technique is to position yourself directly in front of a bare-branched tree and use this almost as a grid through which you view specific elements of the church building. This will allow you to line up some of the more complex shapes such as arch windows and porch doorways that are key features of ecclesiastical buildings. When you come to paint the scene you may choose to paint the branches as positive (darker than the church) or negative shapes (lighter than the church) or, of course, a combination of both.

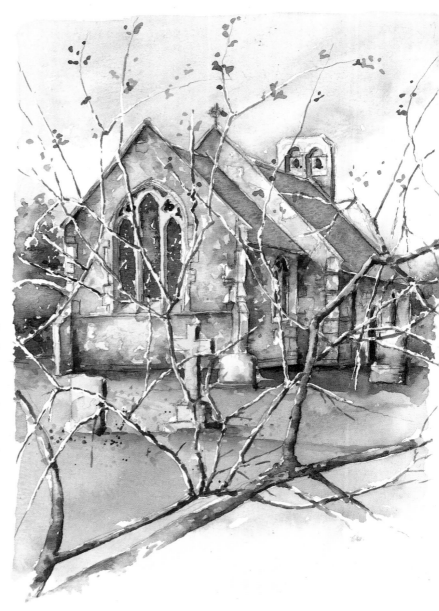

Seaside buildings

Many seaside buildings are constructed using overlapping planks of wood rather like the traditional 'clinker' method of building boats. They are also often painted blue in keeping with the maritime environment. For the artist, painting this type of building is very similar to the approach to brickwork. You know that a wall is made up of hundreds of bricks, or planks, but it would be quite wrong to try to paint them all – so suggestion is the key. Draw as many planks as you feel your picture can accommodate without it looking overcrowded or unnatural, and let your eye take care of the rest. To improve the effect, again select a few planks to emphasize by painting thin shadow lines directly underneath. As white paint fades quickly, a little Raw Sienna loosely washed across the wooden walls will add to the natural effect.

As you will often be painting these buildings under a blue sky, creating blue-

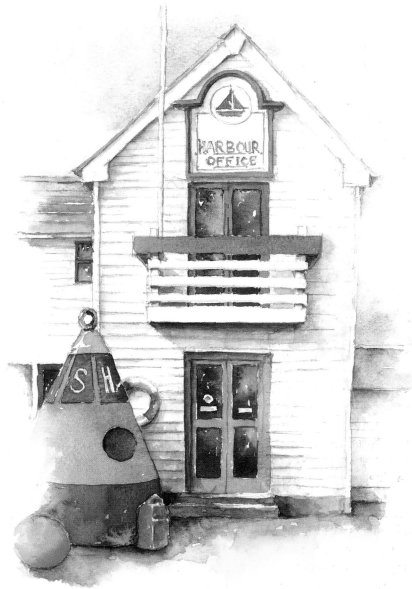

tinged shadows often falling onto blue woodwork, you will need to give careful consideration to creating a variety of tones of blue. It is useful to experiment with a variety of shop-bought blue paints to see just how many different blues you can mix. This is good practice with any colour, but especially one that is so important in defining both sky and shadow colours.

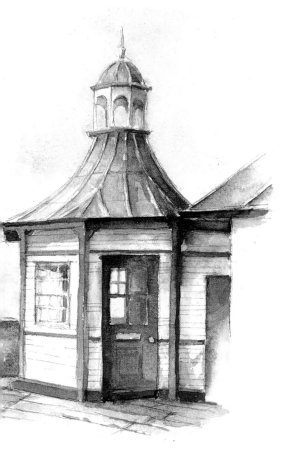

◀ Pier Kiosk
20 x 15 cm (8 x 6 in)
The blue sky, roofing and paintwork in this scene required much tonal painting and some subtle blue mixes. I recommend that you start to mix several blue paints to maintain a fresh, maritime feel to your seaside paintings.

▲ Harbour Office
29 x 20 cm (11½ x 8 in)
Many of the wooden planks on this building were suggested by both line and shade rather than slavishly drawing every one.

Urban Buildings

Painting in the urban environment presents artists with a range of challenges – every one of which is worth overcoming to find the wealth of buildings that are typical of towns and cities, and the closeness and proximity of different types, styles and ages so often found in just one street.

Painting in towns

Painting in towns or cities can be a tricky business for an assortment of reasons. You are rarely alone on an urban street, so be prepared! It is not easy to sit and sketch when tides of passers-by are forever walking in front of you, behind you and, sometimes, even over you if you are not conspicuous enough. So try to find some public seating. Most towns and cities have either benches or seats in their centres, and these will enable you to sketch in some comfort. But do not try to work on anything that will take you much longer than a few minutes as you can be certain that a bus, coach or delivery truck will park in front of your chosen subject.

Even on the quietest of mornings you will find that pedestrians are about and walking past your subject, rarely stopping, but making their presence felt. They are very much part of the urban environment and are worthy of inclusion. A few quick pencil marks and the minimal amount of paint are all that are required. Rather like the churchyard scene, a mixture of darker and lighter colours can often create the ideal balance.

The rewards of urban painting are, however, certainly worth pursuing. One largely unexplored subject for artists is the

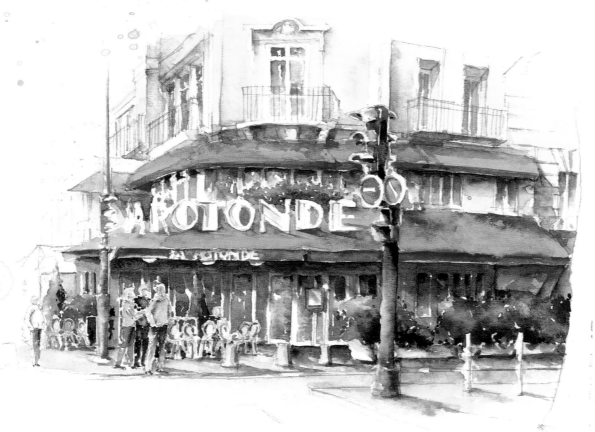

◀ **'La Rotonde' Café**
20 x 30 cm (8 x 12 in)
As this café is so much a part of the urban environment I felt it important to include the visual clutter that surrounds it – lamp posts, road signs, traffic lights and so on.

architecture above the normal eyeline. We are accustomed to seeing a barrage of brightly coloured and highly seductive shop signs along high streets as we go about our daily business. But how often do we stop to take a look at the windows, architraves and architectural ornaments that are so often found above the signs and commercial paraphernalia? Many subjects are to be found at this visual level, and they are worthy of sketchbook studies. Unusually, in this situation, you will be looking up and seeing the underside of window ledges and of window frames, so shadows and shading need to be reconsidered.

Unlike rural buildings, urban buildings are seldom surrounded by greenery. As the entire building is usually visible, the shadows will often be longer and contribute more to the shape of the building. For these buildings take your shadow colour from the main brick or stone colour and add a touch of blue. You probably will not be including the sky in your picture, so select a blue that you feel matches the mood. As you will be working quickly, let the water work for you and do not labour over shadows: a few short, sharp dabs of colour onto wet paper are really all you need.

Terraces

One particular feature of town and city design is the terrace – a simple method of creating several individual buildings that are structurally sound and together look grand in appearance.

Due to the level of perspective drawing required to record these, many artists are a little intimidated at first, but the approach need not be that different from painting buildings in a landscape. The key is to view the line of buildings as having three levels – background, middle ground and foreground.

The furthest end of the terrace appears to be the smallest as the perspective lines converge towards a point further along on the horizon. The windows and doors are drawn shorter and narrower, with much less detail to be seen. This is the section that is the lightest in tone when painted. The middle of the terrace contains a little more information – maybe window bars, a suggestion of ornamentation on balconies, or railings around basement steps may just become visible. The foreground, which is visually the largest part of the terrace, contains the most information regarding the decoration and structure.

The first wash of the appropriate brick or stone colour is started as a strong wash at the foreground end and slowly diluted towards the furthest distance, creating a lighter tone for the background section of the terrace. This section can probably be left without any other paint added to the fabric of the building. The middle section needs to be painted quickly before the underwash has time to dry. So that no hard line is visible to divide the sections classified as middle, fore or background, the paint used for the middle ground, which is a slightly stronger mix of the underwash, needs to be applied quickly and allowed to bleed softly along the line of the terrace. The final stage is to do exactly the same with the foreground, creating graduated

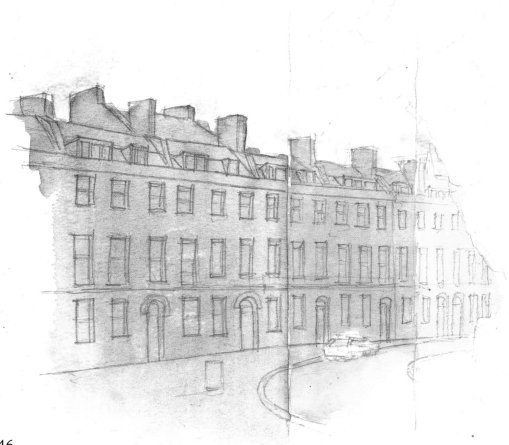

◀ Both linear and tonal perspective work together in painting this terrace as the houses appear to get smaller and lighter in the furthest distance.

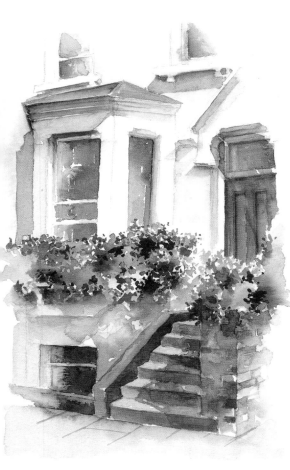

tone along the line of the apparently converging building. Once the brick or stone paint has dried, the doors and windows can be painted using a small brush.

To gain a better feel for the details found on a terrace, it is worthwhile making a study of one particular section. This will allow you not only to keep the information gained in your sketchbook, but will also aid your visual memory when you paint the whole terrace. This is always a slight dilemma for artists – whether to paint an entire terrace or concentrate on a particularly appealing section. So, assuming time allows, why not have a go at both?

◀ This study of one house, part of a long terrace, reveals much about its architecture. Light falling across the features helps to define the whole terrace.

▼ **Bedford Square, London**
25 x 32 cm (9½ x 12½ in).
City squares rarely hold much colour. This scene was created with only four or five paints.

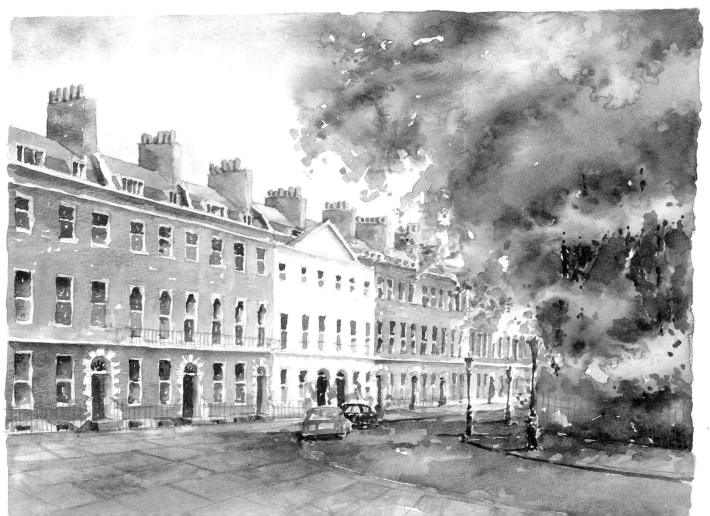

Setting the Scene

No matter where you choose to paint you will find a wealth of visual distractions – lamp posts, 'no entry' signs, cars, tractors, and people going about their daily business. If they are part of the scene that you are going to paint, then it would not be the same without them.

In the country

Farm buildings differ from many others in their structure. They are functional buildings and are, therefore, not necessarily constructed of the most expensive materials. This often means that they age quickly, resulting in interesting textures and shapes within the fabric of the walls.

Many barns and sheds on farms have particularly long roofs. These are ideal to practise the technique of loading a medium-size brush with the appropriate paint mix and dragging it horizontally along the length of the roof. This must be a single stroke: do not stop to reload the brush as this will break the continuity of flow and reduce the effect. Then, straightaway, run another horizontal line of paint directly underneath this, varying the pressure on your brush. This will result in a slightly broken line, helping to suggest the lines of tiles running parallel along the roof. Repeat this five or six times. There may well be more lines of tiles than this, but the idea is to create an impression of the building's roof, rather as when painting brickwork, and not a photographic likeness. Use a mixture of French Ultramarine or Cobalt Blue and Burnt Umber for slates, or Raw Sienna and Burnt Umber for tiles.

Old farms can be particularly picturesque places with their ramshackle barn doors, harvesting machinery and old rusting implements scattered around the courtyards.

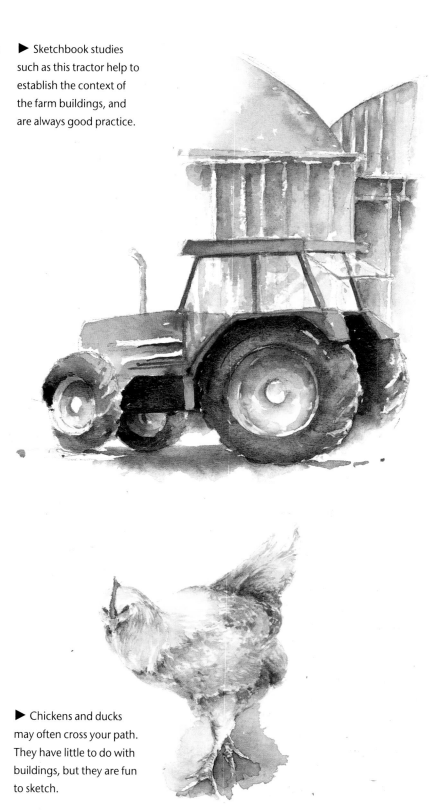

▶ Sketchbook studies such as this tractor help to establish the context of the farm buildings, and are always good practice.

▶ Chickens and ducks may often cross your path. They have little to do with buildings, but they are fun to sketch.

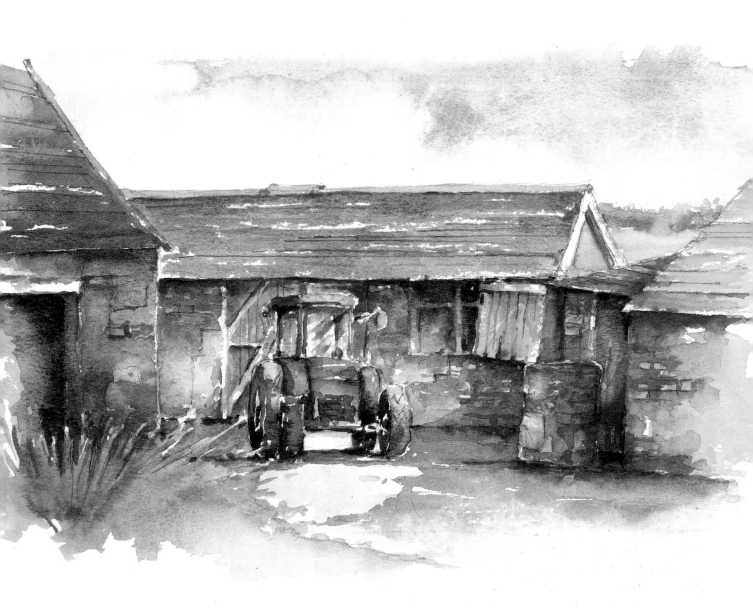

You may even find ducks and chickens loose in the straw-strewn yard. Modern farms, however, are more concerned with agricultural effectiveness and production than with visual qualities. Yet you will still find subjects to paint and to make sketchbook studies of. Modern tractors, for example, may at first appear to be quite angular and unattractive, but these objects need to be seen in context. Viewed against a large, corrugated iron barn the shapes and angles tend to fall into place. The colours of tractors can be particularly appealing.

A specific word of warning needs to be offered on this subject – do not be tempted to use black to paint the prominent and very solid-looking tractor tyres. Black has the effect of 'flattening' subjects to which it is applied. Instead use a strong mixture of French Ultramarine and Burnt Umber. This will produce a much more lively paint, adding colour to any tractor or tyre that you choose to include in your composition.

The colour and tone of the sky will determine the strength of light and shade on buildings.

▲ **Farmyard Scene**
23 x 33 cm (9 x 13 in)
The visual clutter found around both old and modern farms often results in a pattern of light and shade. Study the shapes of the ground shadows, and try to paint these as 'once only' washes.

In the town

Many of the aspects that you might try to avoid in a rural setting, such as cars, vans and trucks, are such an integral part of the urban environment that it is not a question of avoiding them, but rather a question of how they can best be included in your painting. On some occasions the unavoidable cars that are to be found on every street at every time of day may well be painted as they appear, using their actual colours. The figures are also treated in the same way, painting the colours of their clothes as they appear. This creates a unity within the scene, but requires that the tones are balanced between figures, cars and buildings. Thus a particularly strong blue shadow on a car would not match a soft, violet shade on the building and you would need to adjust this discrepancy. Equally, the clothes cannot be noticeably lighter or darker than the colours of the cars and building.

In most building compositions the only areas of concern are the building and surroundings that are usually on either side or behind the main subject. In cities and towns, however, the people and traffic are invariably in front of the building and require much more care in painting.

These human elements can, however, easily distract attention away from the buildings. To avoid this, try sketching the whole scene and then paint the buildings, leaving the foreground cars as negative shapes. This technique works very well visually as the cars and figures appear as ghostly figures or shapes, and the eye is drawn straight past them to the buildings.

▼ 'Le Dome' Café
20 x 30 cm (8 x 12 in)
Few colours were used, but many tones created, in this street scene, making the picture alive with the bustle of urban activity. The watery shadows and soft highlights needed careful balancing.

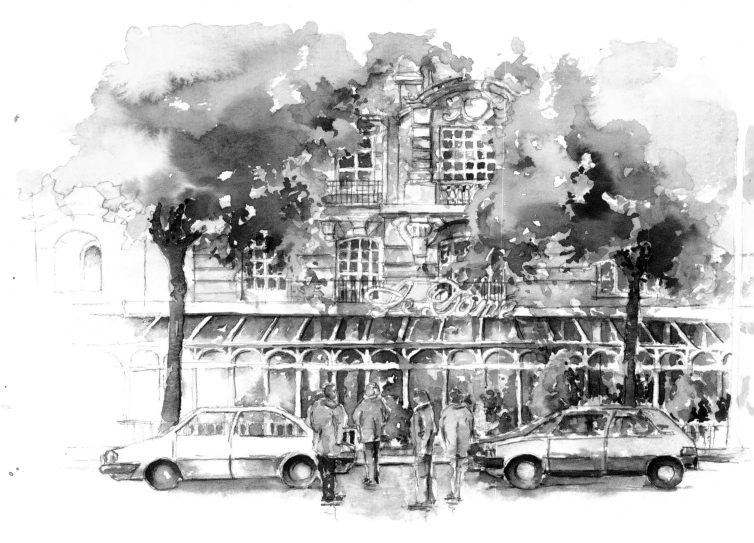

As is often the case, a combination of both techniques can work particularly well. If a few sections of the foreground cars and figures are partially painted, and the remainder left unfinished, the picture can look fresh and spontaneous. This effect can be achieved by using a lot of wet paint applied to wet paper. This will dilute and dry to a particularly soft, pastel shade. White cars and figures wearing light shirts or suits are ideally suited to this technique as the fading out of the watery paint is not quite so effective when strong colours are used.

▼ Even when leaving cars as negative shapes you can create a more atmospheric sketch by lightly painting some of the shapes and colours that are visible through the windows.

▲ None of the foreground figures in this study are complete, but this adds to the impression of movement and enhances the 'snapshot' feeling of the study.

French Farmhouse

*The rustic charm of this rickety, yet still inhabited,
French farmhouse proved to be an
irresistible subject. I could see even before starting to paint
that I would be able to use most of my favourite
techniques – lots of watery washes, wet-into-damp
applications of paint, and spattering on the foreground.*

▶ First stage

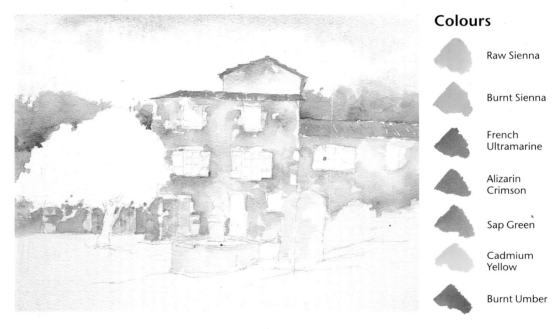

Colours

Raw Sienna

Burnt Sienna

French Ultramarine

Alizarin Crimson

Sap Green

Cadmium Yellow

Burnt Umber

First Stage

To create the warm Mediterranean tones of this rustic farmhouse I started with a mixture of Raw Sienna and Burnt Siennà, which I washed onto dampened paper with a medium size brush, working carefully around the doorways and windows. While this was still damp, I touched some pure Burnt Sienna onto the paper and allowed the colour to bleed outwards from the point of contact (wet-into-damp). I waited until the paper was fully dry before picking out the lines of the tiles using a small brush and more Burnt Sienna. Sometimes you will need almost to 'draw' onto a painting in the early stages to create key areas of detail.

Second Stage

To capture the warmth of the day, I mixed together French Ultramarine and a touch of Alizarin Crimson. Still using a medium brush, I washed this mixture across the roof and the building to the right of the farmhouse. I then changed to a smaller brush and picked out the panes of glass in the windows, leaving the white window bars gleaming in the hot sun. To increase the sense of space and distance I painted the

foreground tree using a mixture of Sap Green, Cadmium Yellow and French Ultramarine. I dampened the tree shape first, then dropped a succession of watery paint mixtures onto it.

Finished Stage

To create the foreground I loaded a small brush with a strong mixture of Raw Sienna and flicked it onto a dry underwash of Raw Sienna and Burnt Sienna, mixed together in my palette. As this was drying, I mixed small puddles of Burnt Umber and Alizarin Crimson in my palette and successively dipped my brush into each and flicked it onto the paper, around the fountain, increasing the quantity of paint in the deeper shaded areas.

To finish the scene I painted the foreground post in the colours used so far, making sure that the crimson shadows clearly distinguished one side from the other, so enhancing the three-dimensional appearance of the scene.

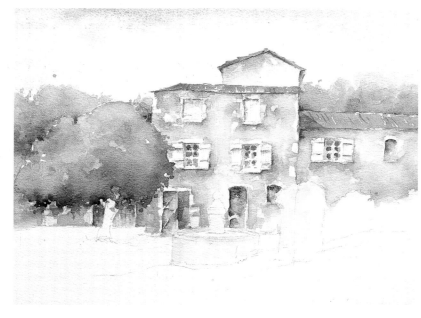

▲ Second stage

▼ **French Farmhouse**
23 x 28 cm (9 x 11 in)

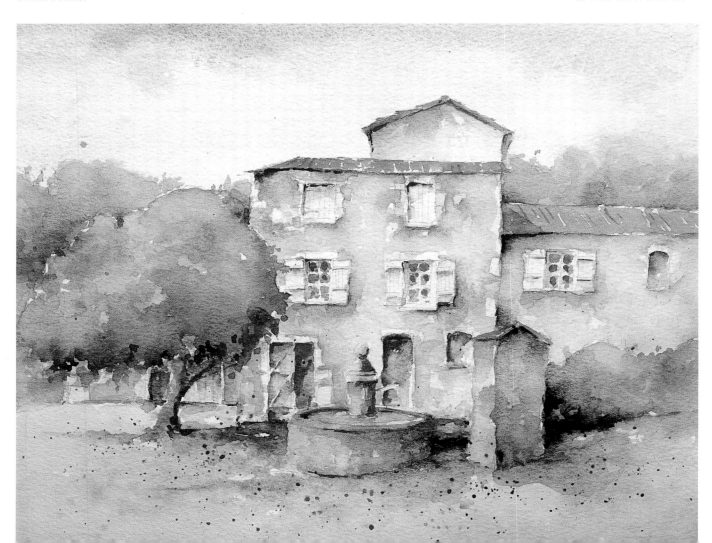

City Buildings

Even the most modern of city scenes can hold some appeal for the artist. High-rise glass-fronted buildings sit uneasily side by side with old stone and concrete structures. Their height dominates the scene. Perhaps that is why even the smallest flash of colour on the ground takes on a particular prominence and becomes a centre of attraction despite their relative scale.

▶ First stage

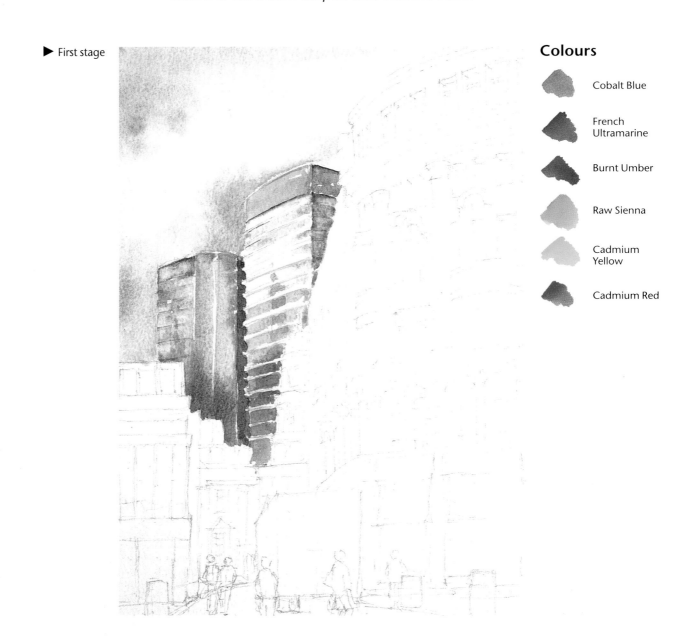

Colours

Cobalt Blue

French Ultramarine

Burnt Umber

Raw Sienna

Cadmium Yellow

Cadmium Red

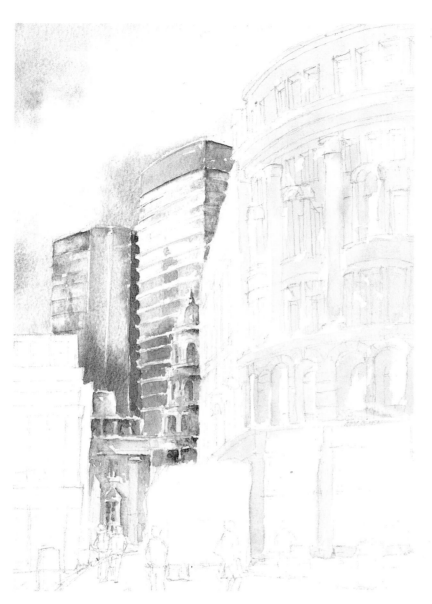

First Stage

One of the most noticeable features of this scene was the way in which the cloudy sky was reflected in the tall glass office blocks of the city. The strong light also created some noticeable reflections.

I washed a mixture of Cobalt Blue and French Ultramarine onto damp paper and 'lifted' the paint to create the cloud shapes using scrunched-up kitchen paper. I then applied the same mixture to the glass tower blocks, using horizontal strokes to follow the lines of the building. I introduced a little Burnt Umber to the mixture to paint the darker reflections of 'bouncing' light.

Second Stage

The next stage was to lay an underwash across the warm stone buildings that made up the middle and fore grounds. Using a medium brush, I applied a watery wash of Raw Sienna to dry paper, using broken brushstrokes and working carefully around the windows. I then returned to a small brush to pick out some of the architectural details in the middle ground, mixing Raw Sienna, Burnt Umber and French Ultramarine to paint onto the recesses of the buildings. This created the negative shapes of the figures and parked truck in the immediate foreground. These helped to define the foreground and 'set the scene' more clearly.

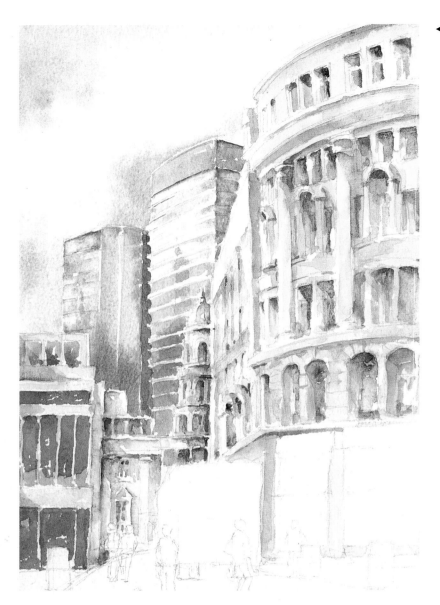

◀ Third stage

Third Stage

To create the 'body' of the buildings I returned to the initial sky mixture. Using a small brush, I applied this paint to the remaining windows, working onto dry paper to maintain control of the flow of paint. I then added this mixture to the building colour (the stone mix) and painted the shadows in the recesses of the windows. I ran a thin line of paint along the underside of the window frames, and then 'pulled' the paint around the rest of the inset using plain water. This technique creates shadows underneath protruding features such as architraves, adding to the three-dimensional appearance.

Finished Stage

This city scene was completed by the addition of the flashes of colour that make otherwise dull urban streets come alive. I used a small brush to pick out some of the lettering on the blinds and windows and to pick out the colours on the clothing of the figures. The final touches involved painting some of the least significant features, but those that added to the balance of the overall scene – the bright orange litter bins. I mixed their colour with Cadmium Yellow and a touch of Cadmium Red. It is these finishing touches that make the difference to a painting, and can prevent a town or city scene from looking dull or flat.

▶ **City Buildings**

30 x 20 cm (12 x 8 in)

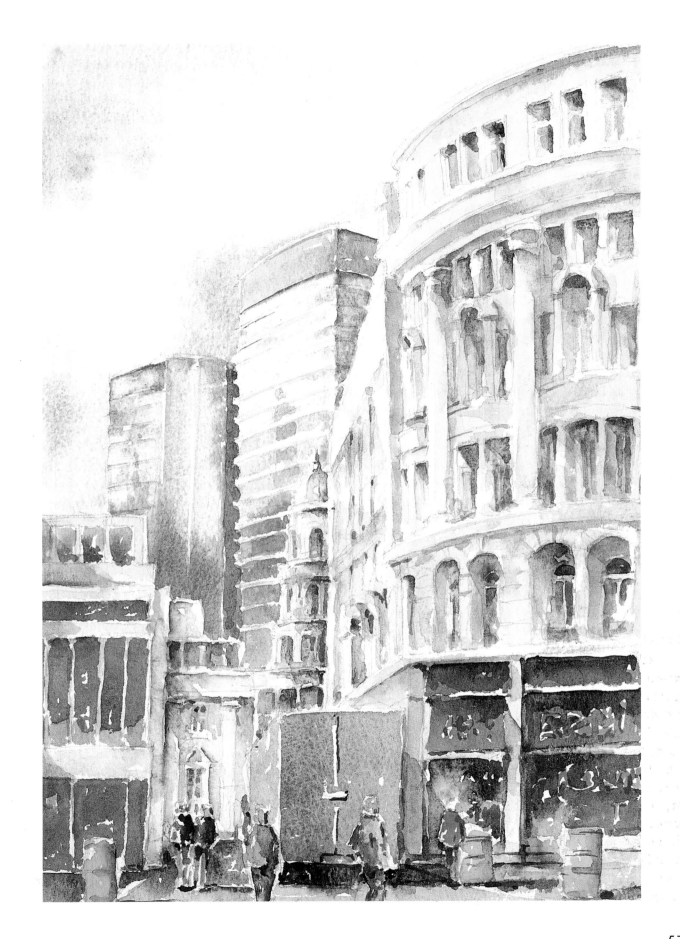

Country Cottage

The high vantage point made this scene particularly appealing. Not only did I have a view of a most attractive cottage, but also of a gentle landscape, rolling down to a flowing river and away into the far distance. The lighting cast deep violet shadows horizontally across the road, giving the scene an even greater appeal to any watercolour artist.

▶ First stage

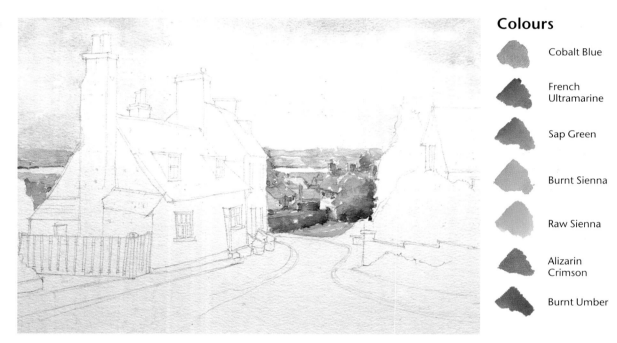

Colours

Cobalt Blue

French Ultramarine

Sap Green

Burnt Sienna

Raw Sienna

Alizarin Crimson

Burnt Umber

First Stage

I established the backdrop against which this lovely old cottage was to be viewed by first painting the sky with a mixture of Cobalt Blue and French Ultramarine, washed onto damp paper. As this dried I blotted out lower areas of the sky with kitchen roll to create the clouds. I used the same colours to paint the river that ran through the middle ground. As this dried I mixed a little Sap Green with the sky blue and painted the furthest hills and fields, maintaining the blue emphasis and enhancing the effect of distance. I painted the middle-ground rooftops using a watery Burnt Sienna.

Second Stage

As this all dried I began to consider the foreground. I added more Sap Green to the sky mix and continued to paint the trees and bushes on the right. While the green paint was still wet I increased the amount of French Ultramarine in the mixture and painted the shaded side so that the darker mix bled gently.

Next I applied an underwash to the main cottage, using Raw Sienna for the roof, and

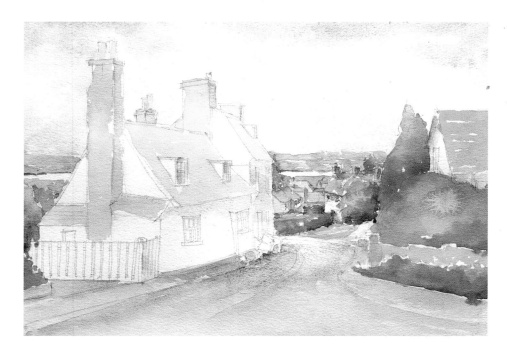

◀ Second stage

French Ultramarine and Alizarin Crimson for the shadows on the front wall.

Third Stage

I mixed a stronger wash of Burnt Sienna and, using a small brush, dragged the paint along the line of the roof using broken brushstrokes to allow the underwash to show through. When it came to painting the chimney stacks I ensured that the shaded side was painted with the same dark tone as the roof, leaving the underwash to do most of the work for the light side.

As soon as these washes had dried, I set about suggesting the fabric of the building by picking out a few tiles on the roof with short, sharp, stabbing brushstrokes, and the bricks on the chimney stacks by suggesting a few positive and negative bricks using Burnt Sienna and Burnt Umber.

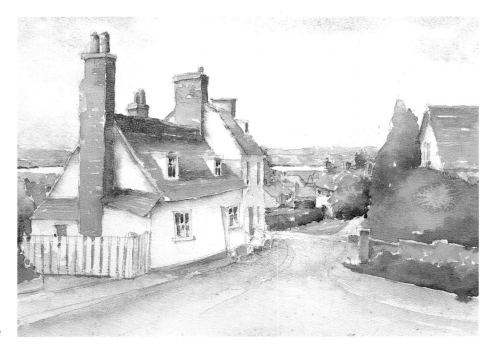

▶ Third stage

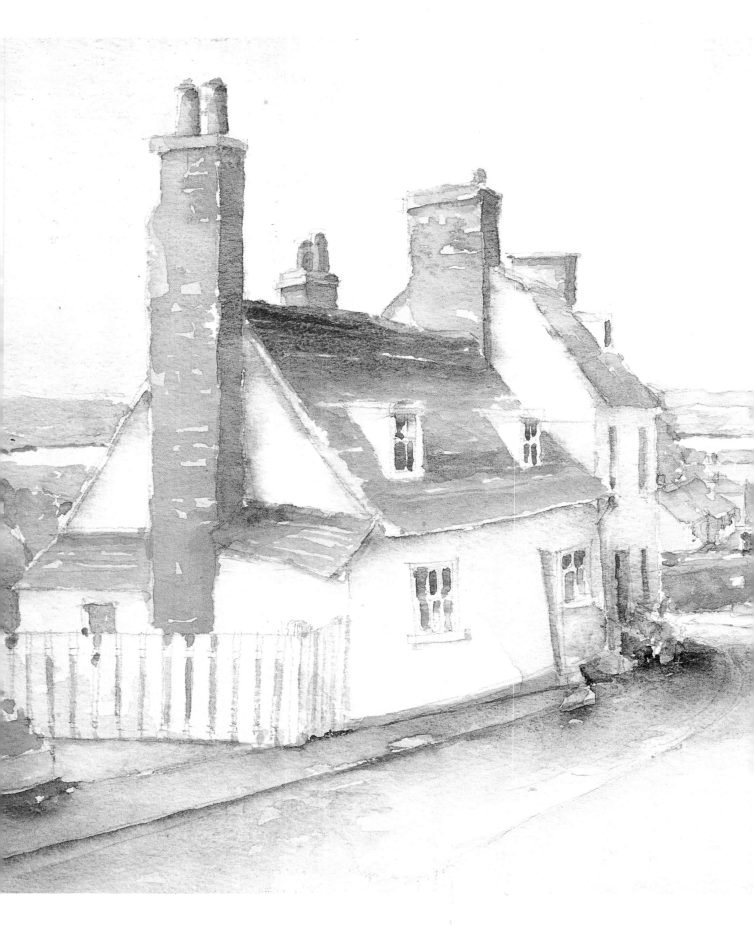

Finished Stage

The final stage was to visually anchor the buildings to the ground. To do this I created a mixture of French Ultramarine and Alizarin Crimson, and just a touch of Burnt Sienna to act as reflected colour. This was then washed along the line of the road, using a large brush and working onto dry paper to allow the tooth of the paper to create a few flecks of white which 'sparkled', acting as highlights. When this had dried, I used the same mixture, but with a small brush, and reinforced the line that separated the road from the pavement, completing the entire scene.

◀ **Country Cottage**
24 x 33 cm (9½ x 13 in)

Lighthouse

The seaside is usually a good place to find an array of buildings that are both visually and historically unusual. I simply could not ignore this towering lighthouse, which stood out so proudly against the blue summer sky. The unusual proximity of this to the textures of the fishermen's cottages in the foreground made the subject even more attractive.

▶ First stage

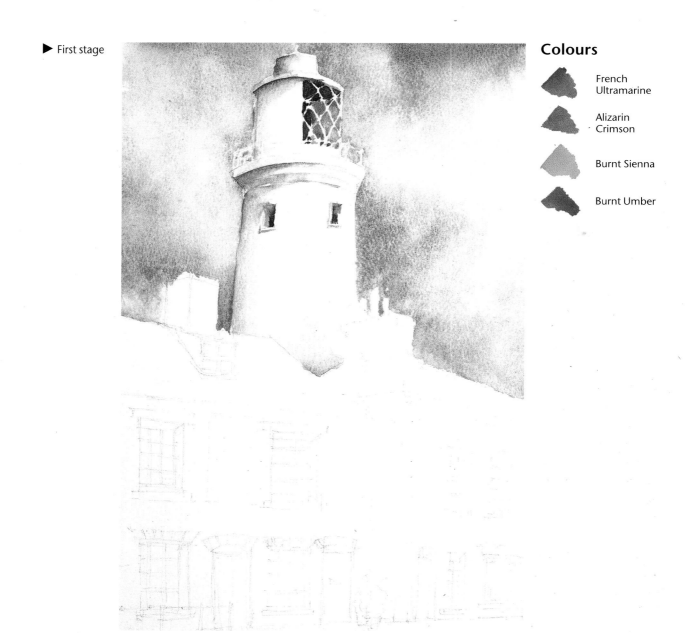

Colours

French Ultramarine

Alizarin Crimson

Burnt Sienna

Burnt Umber

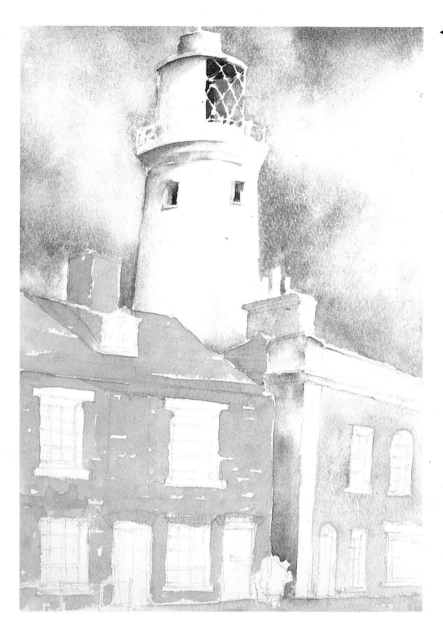

First Stage

The sky was a particularly dominant part of this composition as well as being the backdrop against which the white lighthouse could be viewed. I washed the blue sky onto damp paper using French Ultramarine and working around the lighthouse. I then picked up a little sky colour and mixed this with a touch of Alizarin Crimson and, using a medium brush, applied the softest of washes along the edge of the lighthouse, maintaining its overall white tone. I used a small brush to paint between the white window bars of the lamp housing.

Second Stage

I painted the nearest brick buildings with a mixture of Burnt Sienna and Burnt Umber so that the lighthouse would appear to be visually sandwiched between the sky and the foreground buildings. Working onto dry paper, I applied the paint rapidly, using broken brushstrokes to allow a few flecks of pure white paper to show through to act as highlights.

I painted the furthest buildings using the sky colour and a touch of Burnt Umber with a little Alizarin Crimson added to shade the white stucco sections.

63

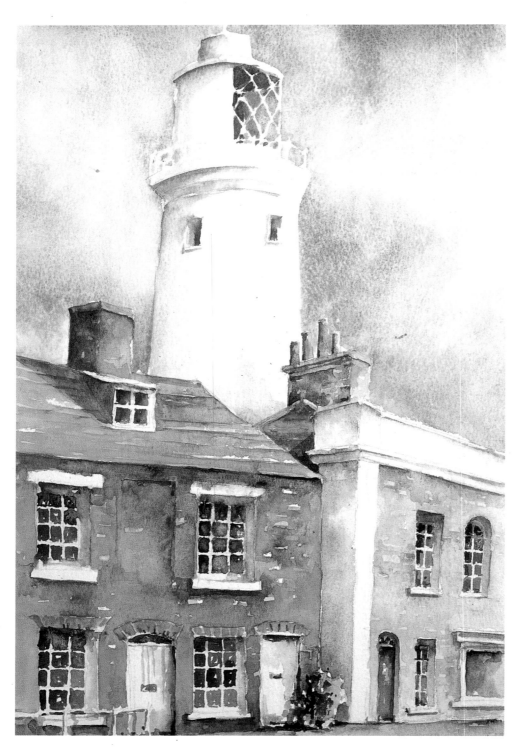

Finished Stage

I added a little more Burnt Umber to the underwash mix and a lot of water, then applied this to the building on the right, working onto dry paper and picking out selected bricks. I painted a shadow under the window ledges and doorway, and reinforced the shaded side of the chimney. Finally, I completed the red brickwork and roof tiles of the cottage on the left. I dragged a small brush loaded with Burnt Sienna irregularly along the edges of the roof tiles. I used the same mix for the brickwork, but applied in patches, allowing the underwash to represent mortar.